ANATOMY
OF STYLE

French Edition
Editorial Director
Julie Rouart

Administration Manager
Delphine Montagne

Editor
Gaëlle Lassée

English Edition
Editorial Director
Kate Mascaro

Editor
Helen Adedotun

Translated from the French by Kate Robinson

Design and Typesetting
Tiphaine Bréguë

Copyediting
Lindsay Porter

Proofreading
Nicole Foster

Production
Christelle Lemonnier
and Titouan Roland

Color Separation
Bussière, Paris

Printed in Slovenia by DZS Grafik

Simultaneously published in French as
Que le style soit avec vous!
© Flammarion, S.A., Paris, 2020

English-language edition
© Flammarion, S.A., Paris, 2020

87, quai Panhard et Levassor
75647 Paris Cedex 13
editions.flammarion.com
20 21 22 3 2 1
ISBN: 978-2-08-151353-2
Legal Deposit: 10/2020

ANATOMY OF STYLE

SOPHIE GACHET

Flammarion

"Style
is something
each of us
already has,
all we need
to do
is find it."

Diane von Furstenberg

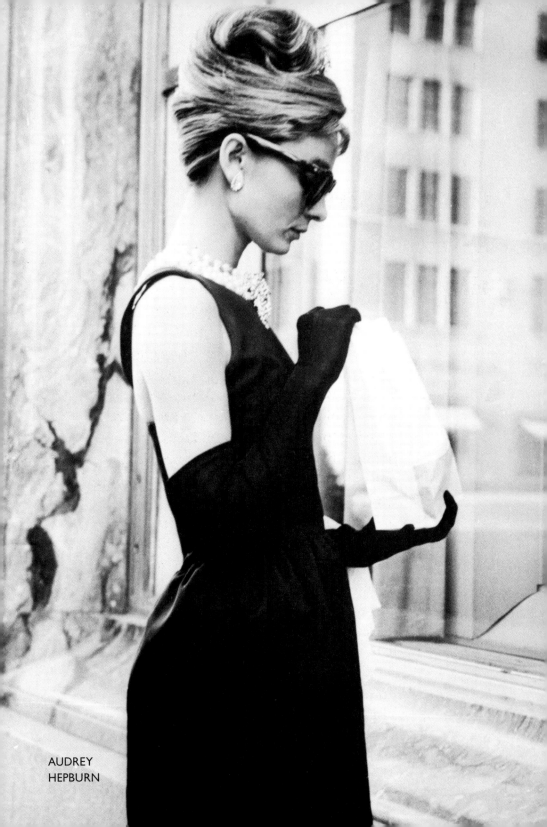

AUDREY
HEPBURN

When does fashion blossom into style?

Why do some women look like they're playing dress up while others are the epitome of elegance? Celebrities have given the question a lot of thought—they know that a good sense of style can help build a career. Before the days of red-carpet mania, some fashion designers helped actresses by dressing them for their roles. The brand became their style and they in turn became muses to the designers—like Audrey Hepburn, who wore outfits by Hubert de Givenchy, including the famous little black dress in the film *Breakfast at Tiffany's*. Or Catherine Deneuve, whose look in *Belle de Jour* was designed by Yves Saint Laurent. So what does it take to become a woman with style? A signature garment. Katharine Hepburn's masculine pants, Jackie Onassis's maxi sunglasses, Marilyn Monroe's glamorous dresses, Grace Kelly's handbag, Jane Birkin's white T-shirt/1970s jeans/wicker basket: in short, you know exactly who you're dealing with.

"Style is a way to say who you are without having to speak,"

says stylist-to-the-stars Rachel Zoe. Which is why it's so important to get your look right, and stay true to your personality. When Jennifer Lopez wears a vampy dress, she does it with purpose. When Cate Blanchett repeatedly sports pantsuits on the red carpet, there's a reason. Wearing your clothes with intention is a way to create a style.

This book's mission is to decipher the stylistic quirks of VIPs: Céline Dion's penchant for the head-to-toe designer look; Angelina Jolie's passion for strapless dresses; Emily Ratajkowski's affinity for the crop top; Billie Eilish's fascination with all things oversize—they created signature looks through repetition. This book is a guide to style, filled with ideas. Draw inspiration from a star, copy their tricks, steal the looks you like: it's time to create your very own style, taking cues from these examples. Tuck in the front of your sweater, add a colorful bag to an all-white outfit, dare to pair sneakers with suit pants; these tips are easy to replicate and will

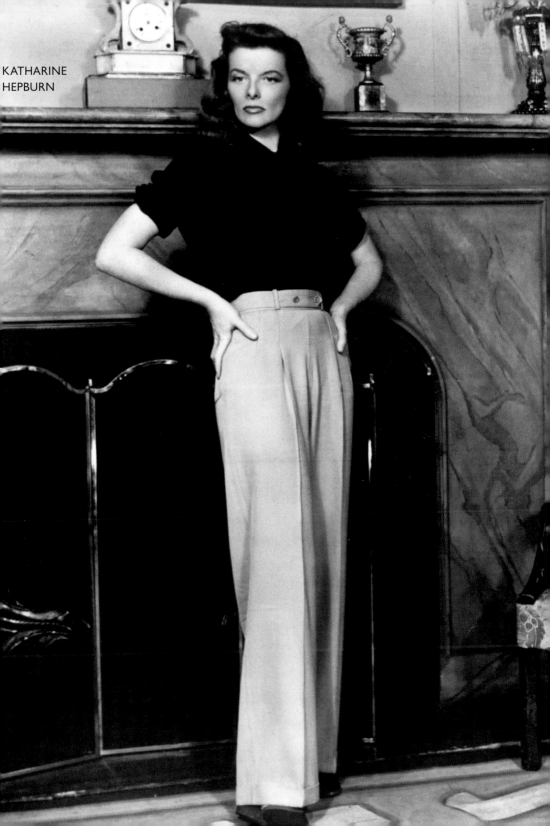

KATHARINE
HEPBURN

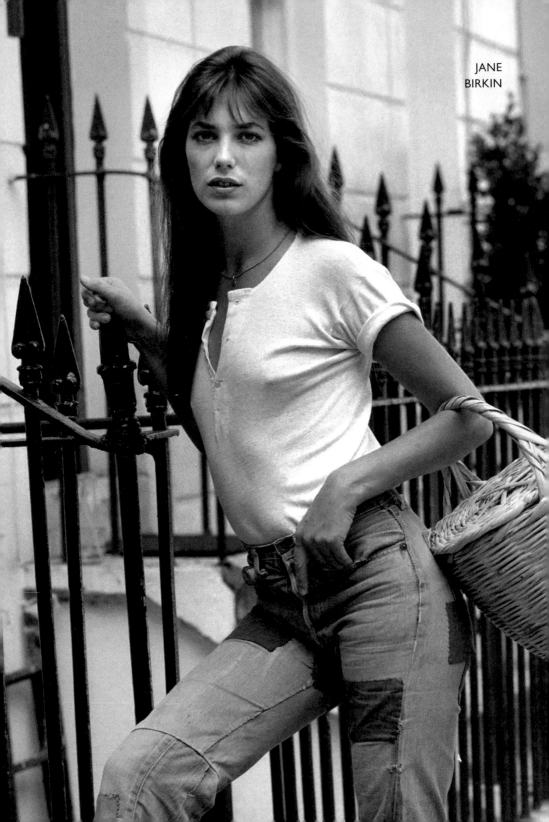

JANE
BIRKIN

help you avoid the pitfalls of humdrum style. In this book where all styles are welcome, wardrobe essentials play a leading role: trench coat, turtleneck, white shirt, or jeans—just because they're basics, doesn't mean you should wear them without measured consideration. And finally, we'll take a look at the best fashion faux pas: the ones that prove you can have fun with fashion and that bold choices are the way to change preconceived notions. We'd be the last ones to advocate for a fashion police to enforce playing it safe with head-to-toe black. Women want to experiment with clothes these days, so dare to wear bright colors, try unusual proportions, and bust out the prints. We're living in a time when anything goes.

"Fashion passes, style remains,"

said Yves Saint Laurent. One thing is for sure: style will always be in fashion. So have fun creating or building on your own style by drawing inspiration from the suggestions in this guide. May the style be with you!

14

STYLE ICONS

96

SHE'S GOT THE LOOK

STYLE
ICONS

What if having style were a skill you could learn? The women in this book look effortlessly cool, but we know they thought long and hard about how to develop a head-turning style. The style you invent should reflect your personality. If it doesn't, it's destined to fail. So, which style do you prefer? Minimalist? Rock 'n' roll? Fun? Quirky? Sexy? Boho? There are as many possibilities as there are personalities. These celebrities have all taken a stand. One thing to keep in mind: barring the looks reserved for the red carpet, all the outfits presented in this book can be easily copied and none requires an advanced degree in shopping. Ultimately, having style comes down to knowing how to work with what's already in your closet—and having quality pieces that will last longer than a single season. As everyone knows, "Fashion goes out of fashion, style never does" (Coco Chanel).

BORN
**November 3, 1995,
Los Angeles,
California, US**

OCCUPATION
Model

DEFINING
FEATURE
**Gives casual style
fashion cred**

KENDALL JENNER

Sexy casual

IT'S NOT EASY TO MAKE YOUR MARK AS A KID FROM THE
KARDASHIAN GALAXY, BUT KENDALL TOOK A DIFFERENT
PATH THAN HER SISTERS: SEXY CASUAL. SHE ALWAYS PAIRS
A FEMININE PIECE WITH SOMETHING FROM THE MASCULINE
VERNACULAR, LIKE JEANS, SNEAKERS, OR A BLAZER.
THAT'S ALL IT TOOK TO MAKE HER A SUPERMODEL.

KENDALL'S *style secret*

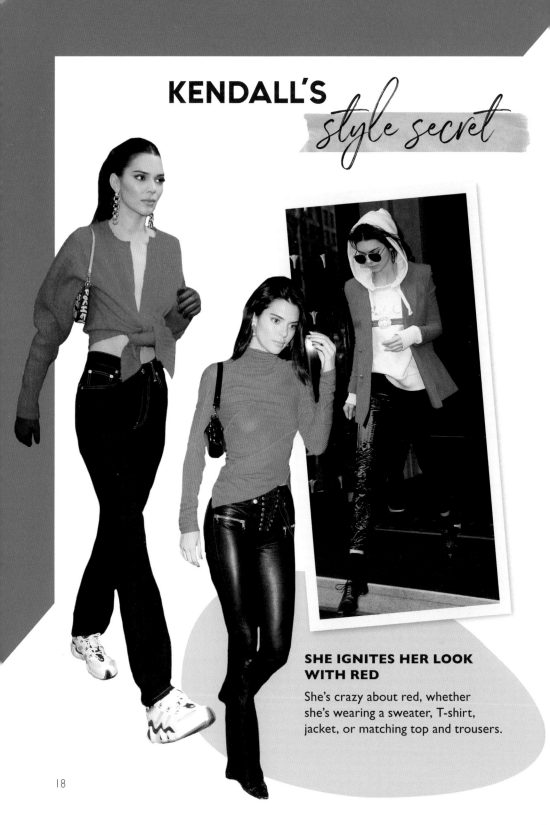

SHE IGNITES HER LOOK WITH RED

She's crazy about red, whether she's wearing a sweater, T-shirt, jacket, or matching top and trousers.

Kendall found herself in the limelight at the age of eleven, when she appeared in the E! reality TV series *Keeping Up with the Kardashians.* In the midst of all the family drama, the pretty brunette stood out for her style, and brands quickly realized that she could be the perfect muse. Her career really took off when she was nineteen and became a Victoria's Secret Angel. With more than 125 million Instagram followers, she is now a major influencer whose sexy casual style is a reference for fashion mavens.

HER FAVORITE DESIGNERS

Balmain, Atelier Versace, Alexandre Vauthier, Dundas, and Giambattista Valli: for events, she opts for designers who excel in sexy. For everyday wear, she likes to try out small labels like Sunday Best, Cherry, and Warp + Weft. They can be tricky to track down, as some of these brands only last a season.

HER KILLER DETAIL

A pochette bag worn tight under the arm. It's even better when paired with a basic look, and if the bag has personality. Kendall's bag collection contains all kinds of little pochettes.

" My style is a little edgy but comfortable. I like being comfortable, for sure, and kind of casual."

Kendall Jenner

STEAL THIS IDEA

A V-neck sweater, miniskirt, and oxfords. The mix of casual-sexy with a masculine touch is the point-scoring Kendall cocktail.

HER 3 ICONIC LOOKS

She doesn't do traditional on the red carpet: transparent eveningwear is her thing.

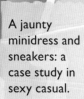

A jaunty minidress and sneakers: a case study in sexy casual.

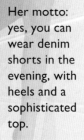

Her motto: yes, you can wear denim shorts in the evening, with heels and a sophisticated top.

BORN
**April 18, 1987,
Plymouth, UK**

OCCUPATION
Model

DEFINING
FEATURE
**Rarely seen out
without a coat**

ROSIE HUNTINGTON-WHITELEY

Minimalist

SHE SPENT HER CHILDHOOD ON A DEVONSHIRE FARM, BUT BECAME A SUPERMODEL SOON AFTER MOVING TO THE UNITED STATES. HER MOTTO: IT ALWAYS PAYS TO BE STYLISH. COPYING HER LOOKS IS NO RISKY BUSINESS.

ROSIE'S *style secret*

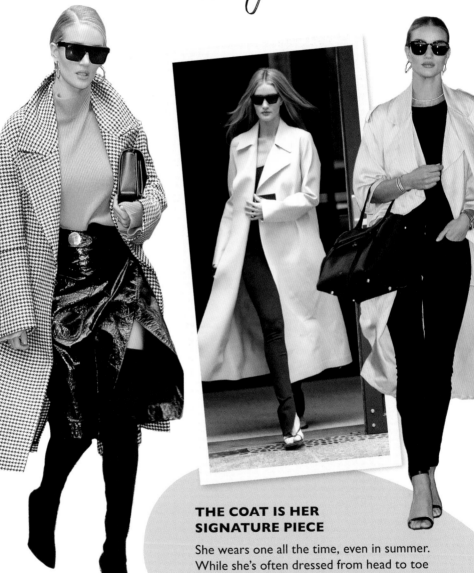

THE COAT IS HER SIGNATURE PIECE

She wears one all the time, even in summer. While she's often dressed from head to toe in black, the color or print of her coat completes her look.

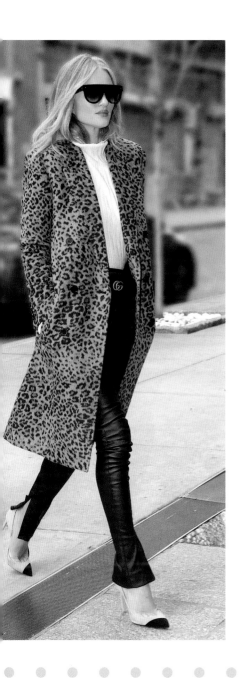

This Victoria's Secret Angel stays in stunning shape by working out every morning. She claims she likes to dress casual, but photos prove that she never leaves the house in sweats and a T-shirt. Whether in a well-cut coat, tailored jacket, close-fitting pants, or a super sexy dress, Rosie knows what it takes to achieve ultimate style. Often seen towering in heels, she'll only be caught in sneakers at her home in Los Angeles.

HER FAVORITE DESIGNERS

She's often seen in jackets or coats by Bottega Veneta, or in pieces by Balmain or Isabel Marant. Rosie is also a big fan of Anthony Vaccarello and never misses an opportunity to wear Yves Saint Laurent. When asked about her favorite clothes, her first response is Azzedine Alaïa.

HER KILLER DETAIL

Lip liner—and a touch of eyeliner. Going makeup-free just isn't her thing.

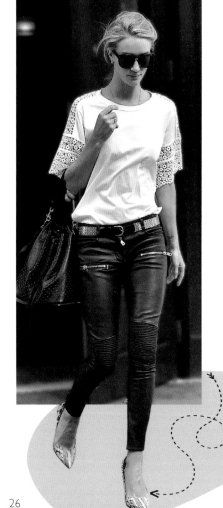

"I look glamorous on the red carpet, but deep down I'm a tomboy who could live in jeans and a T-shirt."

Rosie Huntington-Whiteley

STEAL THIS IDEA

Pointed-toe heels: Rosie's trick is to wear them with slim jeans. Stilettos have the power to inspire self-confidence.

HER 3 ICONIC LOOKS

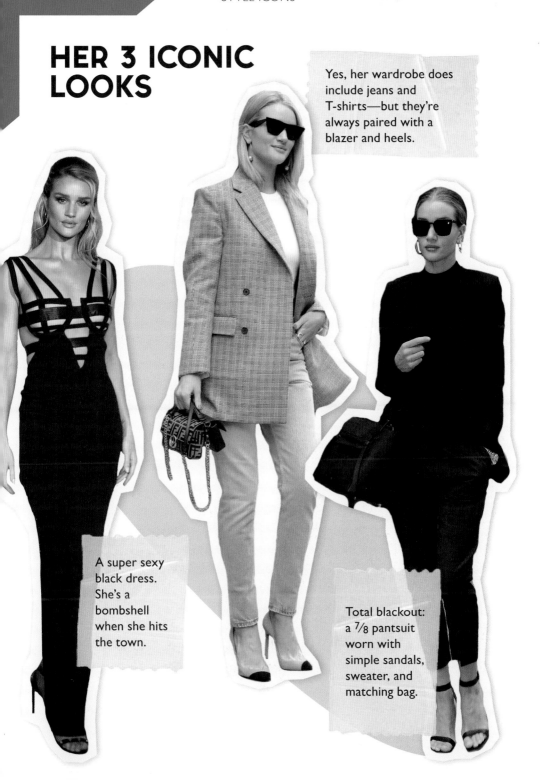

Yes, her wardrobe does include jeans and T-shirts—but they're always paired with a blazer and heels.

A super sexy black dress. She's a bombshell when she hits the town.

Total blackout: a $^7/_8$ pantsuit worn with simple sandals, sweater, and matching bag.

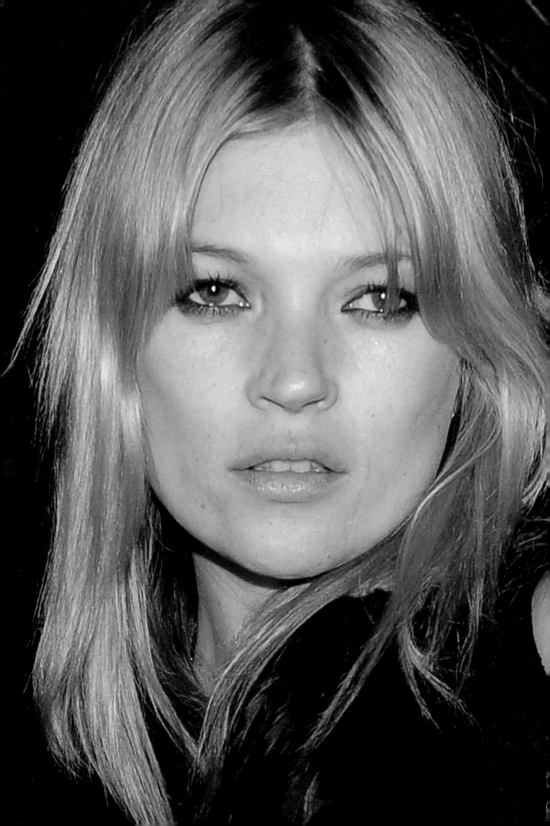

KATE MOSS

Rock'n'chic

BORN
January 16, 1974,
Croydon, UK

OCCUPATION
Model

DEFINING
FEATURE
Her supermodel
career spans more
than thirty years

AN IDOL FOR FANS OF ROCK AND OF THE COLOR BLACK, THE SLENDER BEAUTY SPORTS OUTFITS THAT NEVER GO OUT OF FASHION. RELUCTANT TO GIVE INTERVIEWS (HER RESPONSES ARE ALWAYS SHORT), SHE BUILT HER CAREER AROUND HER INNATE SENSE OF STYLE (ALTHOUGH SHE DENIES GIVING IT ANY THOUGHT WHATSOEVER)— AND HER PARTY GIRL ANTICS. WHICH ALL GOES TO SHOW THAT KATE IS A SUPERSTAR OF COOL.

KATE'S
style secret

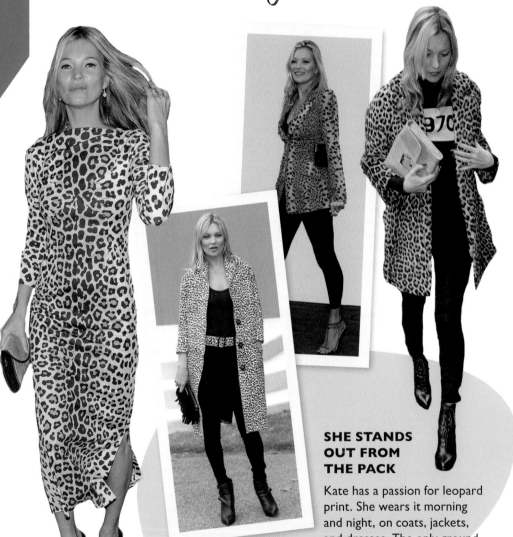

SHE STANDS OUT FROM THE PACK

Kate has a passion for leopard print. She wears it morning and night, on coats, jackets, and dresses. The only ground rule: she keep the rest of her look black.

"Ultimately, dressing is always about attitude, feeling comfortable, and confidence."

Kate Moss

HER KILLER DETAIL

The tuxedo jacket. Kate wears it with everything: with leather pants or over a long evening gown. Whether it has a leather, sequin, or classic satin-lined collar, this is *the* jacket you need to make any look chic.

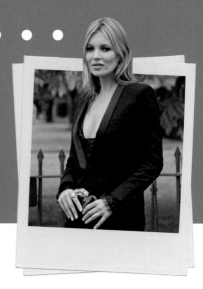

STEAL THIS IDEA

Wear a colorful jacket with a T-shirt and black jeans—and a black bag. You'll never hit a false note with this look, even if the jacket is bold.

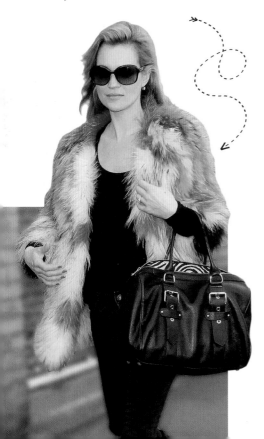

Her style can be summed up in one word: nonchalant. It always seems like Kate has left the house without giving much thought to her outfit, grabbing three basic pieces from her wardrobe. But the results speak for themselves: her instinct is faultless and she has gone years without losing an ounce of cool. She collects ideas that just beg to be stolen, like the all-black look—a perennial hit in fashion circles. To elevate her style above the fray, she adds a seventies touch (bell-bottom trousers or a fringed bag) and in the evening she breaks out the gold or yellow, colors that are sure to shine. Ultimately, her style is made up of a very few looks: that's how you create a fashion identity.

HER FAVORITE DESIGNERS

Her friends John Galliano, Stella McCartney, and Marc Jacobs.

HER 3 ICONIC LOOKS

In 2005, she invented the official uniform for the Glastonbury festival: a man's waistcoat, short shorts, and Wellington boots.

When Kate has had enough of black, she goes for gray. She wears it in pantsuits or as a head-to-toe look.

Black jacket, black T-shirt, black pants, black loafers, and a chic black bag: Kate is buzz-worthy in the simplest of looks.

LUPITA NYONG'O

Fun and flashy

BORN
**March 1, 1983,
Mexico City, Mexico**

OCCUPATION
Actress

DEFINING FEATURE
**Never seen without
a brightly colored
piece**

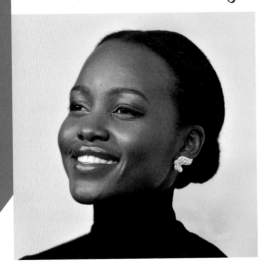

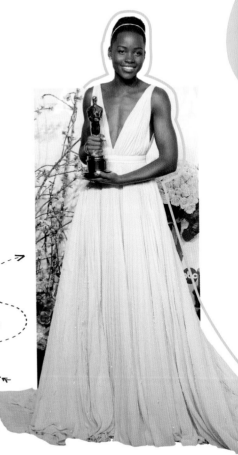

SHE WON AN OSCAR FOR HER ROLE IN *12 YEARS A SLAVE*, BUT LUPITA ALSO DESERVES AN AWARD FOR HER FLAMBOYANT STYLE.

HER ICONIC LOOK

She wore a light blue dress by Prada to accept her Oscar in 2014; super simple and understated, but memorable all the same.

LUPITA'S *style secret*

SHE BREAKS OUT THE RAINBOW

Whether choosing a red or pink coat, a neon or printed dress, Lupita knows her own mind: no matter the season, she's wearing color—the brighter the better.

HER KILLER DETAIL

Matching nail polish to a clutch or dress: it might seem a bit much, but as Lupita puts it, "It's only when you risk failure that you discover things."

35

BORN
**June 7, 1991,
London, UK**

OCCUPATION
Model and actress

DEFINING
FEATURE
**Likes to show
some skin**

EMILY RATAJKOWSKI

Revealing

SHE MADE A NAME FOR HERSELF DANCING TOPLESS IN
ROBIN THICKE'S 2013 MUSIC VIDEO "BLURRED LINES."
IT'S NO SURPRISE, THEN, THAT THIS LOVELY LADY HAS
CONTINUED HER VIP CAREER IN A STATE OF UNDRESS—
OR THAT SHE CREATED THE INAMORATA LINE OF LINGERIE.

EMILY'S

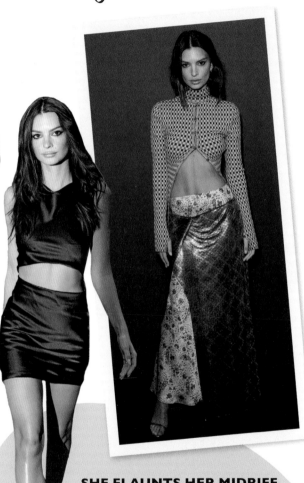

SHE FLAUNTS HER MIDRIFF

It's a way to be "hot" without being
vulgar, especially on the red carpet.
Crop tops and skirts (short or long)
are her choice pieces. Heels or sneakers,
sexy or sporty—she does it all.

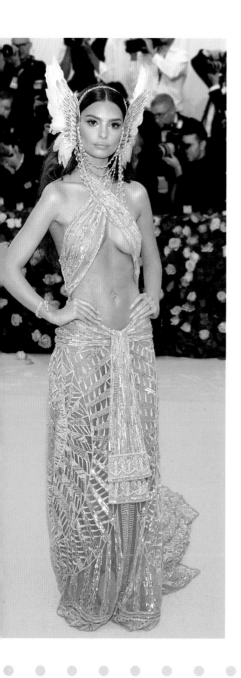

"Yeah, I'm wearing a thong, and maybe that dates back to some anti-woman BS from the past, but now, I like wearing one and it makes me feel good. So, cool. We should celebrate that." A committed feminist, but still very much the epitome of the objectified woman, Emily wants to demonstrate that women can be desirable without being submissive. She's out to prove that adopting a certain kind of femininity doesn't mean she endorses the patriarchy. Often seen wearing a simple crop top and shorts or a miniskirt, she looks strong, not trashy. Well done!

HER FAVORITE DESIGNERS

Jacquemus, Monse, Dundas, Paco Rabanne: when she's on the red carpet, this bombshell turns to designers who celebrate the female form. And now that she has her own lingerie line, she also enjoys collaborating with fresh young talent—an opportunity for her to design a new bra top and long skirt.

HER KILLER DETAIL

Towering high-heeled sandals with very thin straps. Try them—they'll make your legs look longer.

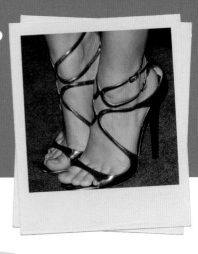

STEAL THIS IDEA

Head out in something skimpy, like a belted shirt or long T-shirt, as if you forgot to put on pants or a skirt. But always pair it with sneakers, for a sporty look.

"When it comes to fashion, women should do what they want. Sexy, unsexy, outrageously sexy, feminine sexy— do whatever you want! That's true freedom."

Emily Ratajkowski

HER 3 ICONIC LOOKS

A mini-bag and a minidress: the Jacquemus style was made for her.

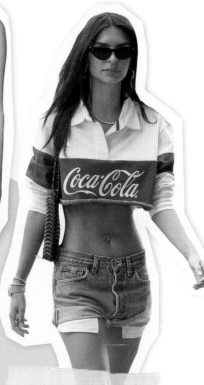

Even on the red carpet, she bares all without seeming to.

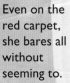

Cropped sweatshirt, faded shorts, sneakers, and washboard stomach: the Emrata legend in the flesh.

41

BORN
November 22, 1996, Tucson, Arizona, US

OCCUPATION
Model

DEFINING FEATURE
Chic, yet very cool

HAILEY BALDWIN

Oversize attitude

JUSTIN BIEBER'S WIFE TURNS EVERY APPEARANCE INTO A FASHION EVENT. EVEN IN SWEATPANTS, SHE MANAGES TO PUT TOGETHER AN AWESOME LOOK. THERE'S NO DOUBT ABOUT IT: THIS MODEL HAS WHAT IT TAKES TO BE AN IT GIRL.

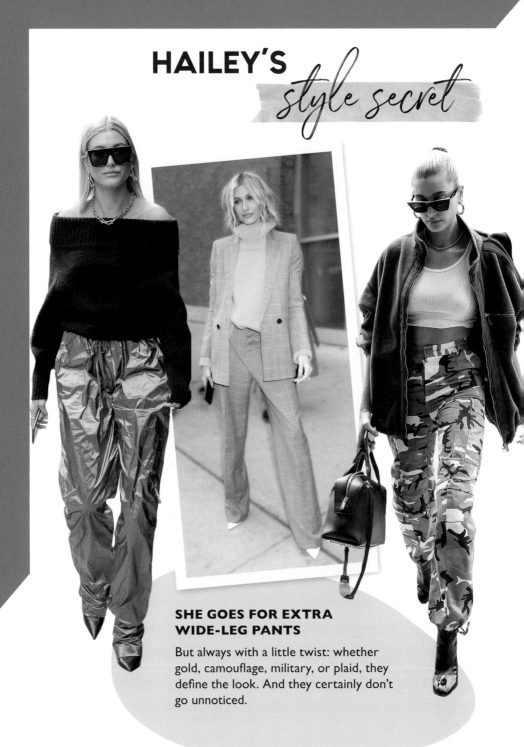

HAILEY'S *style secret*

SHE GOES FOR EXTRA WIDE-LEG PANTS

But always with a little twist: whether gold, camouflage, military, or plaid, they define the look. And they certainly don't go unnoticed.

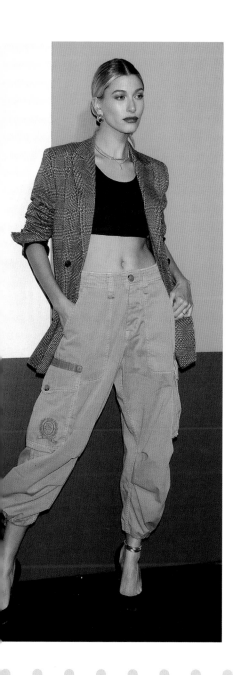

According to Hailey, every wardrobe must include these five cult pieces: combat boots, a leather jacket, an extra-large cashmere sweater, a pair of skinny jeans, and a well-cut T-shirt. So it's easy to copy her style using items you already have at home. Her daytime looks always include an oversize element. In the evening, she goes into bombshell mode, in dresses that accentuate her curves.

HER FAVORITE DESIGNERS

Alexandre Vauthier, Atelier Versace, Zuhair Murad, Ulyana Sergeenko, Tom Ford: the designers she chooses for her red-carpet dresses are all masters of the seductive look. For everyday wear, she turns to Yves Saint Laurent, Bottega Veneta, and Balenciaga, as well as smaller labels like Brandy Melville or sportswear icons like Nike and Vans.

HER KILLER DETAIL

A wool hat worn over loose locks is essential for a street-style look.

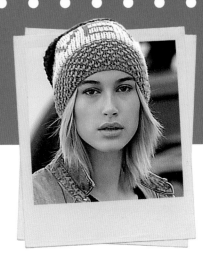

STEAL THIS IDEA

In addition to wearing hats and hoop earrings (which she does at every opportunity), Hailey likes to tuck the front of her sweatshirt into her pants and leave the back hanging out. It's a cool-girl thing.

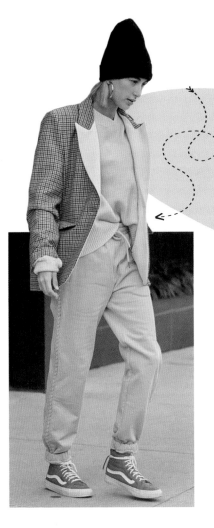

"I like 'effortless' style, wearing super comfortable sportswear pieces."

Hailey Baldwin

HER 3 ICONIC LOOKS

A neon ensemble is a way to draw attention without going too far.

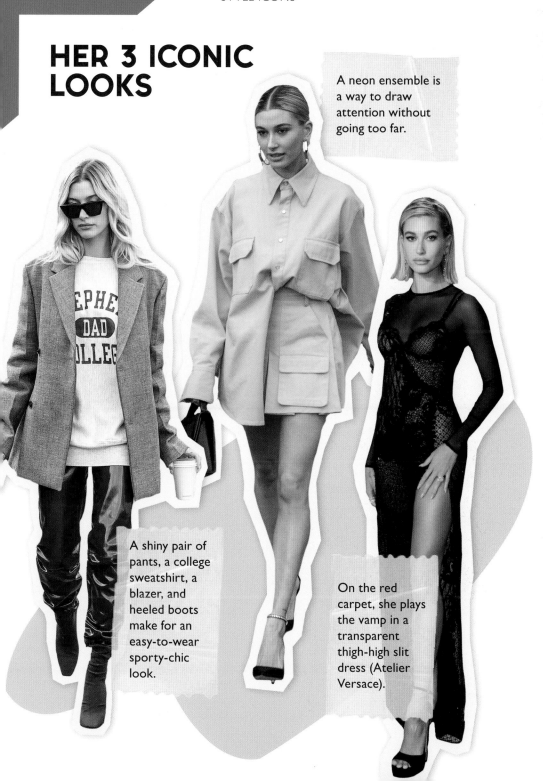

A shiny pair of pants, a college sweatshirt, a blazer, and heeled boots make for an easy-to-wear sporty-chic look.

On the red carpet, she plays the vamp in a transparent thigh-high slit dress (Atelier Versace).

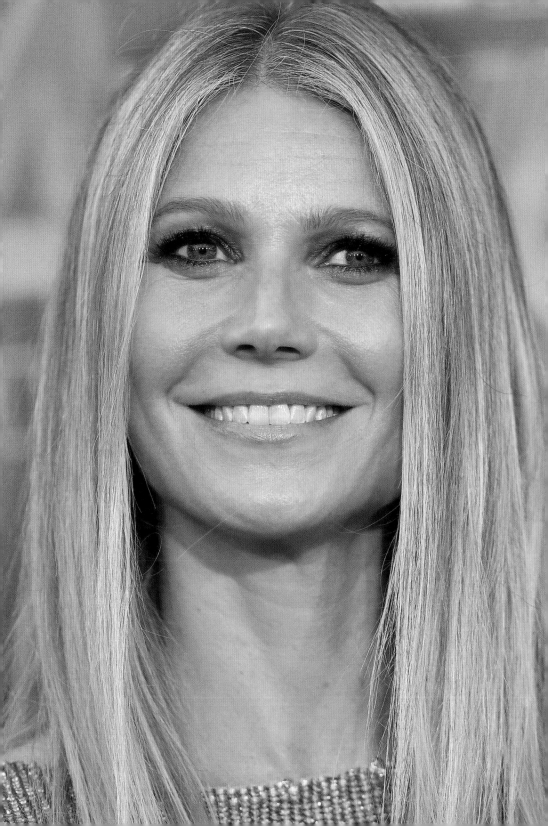

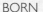

BORN
September 27, 1972, Los Angeles, California, US

OCCUPATION
Actress, lifestyle guru

DEFINING FEATURE
Can switch from shorts to a ball gown in the blink of an eye

GWYNETH
PALTROW

All-American

THE PALE PINK DRESS SHE WORE TO ACCEPT HER OSCAR IN 1999 MARKED THE BEGINNING OF HER CAREER IN FASHION. LIKE A TRUE ALL-AMERICAN, SHE ALTERNATES BETWEEN SPORTSWEAR AND BALL GOWNS, BUT SHE HAS A FEW TRICKS TO STAND OUT FROM THE CROWD.

GWYNETH'S *style secret*

SHE DARES TO GO OUT IN SHORTS

She has no qualms about donning a short-suit, or a short-tuxedo, even on the red carpet. These can make great outfits, especially when worn with heels.

"*It's important to put effort into your clothes. Staying in sweatpants and UGGs all day isn't an option for me.*"

Gwyneth Paltrow

HER KILLER DETAIL

A center part. Whether she's wearing her hair up or down, it's a classic way to stay center stage.

STEAL THIS IDEA

A brightly colored bag with a white ensemble works every time and gives depth to the look.

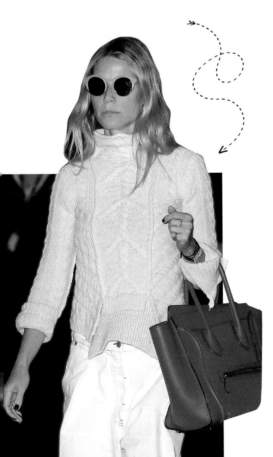

While Gwyneth appears to be a fashionista like most of her fellow actresses, when asked to name her favorite store, she'll answer Murray's, the famous New York cheese shop. She admits that there is no miracle cure for sore feet after a long night in high heels: "I'm so happy just to get home and take them off," she confided after one interminable cocktail hour. Along with her lifestyle website Goop, she launched a clothing line— G. Label—inspired by her outfits. Thanks, Gwynnie!

HER FAVORITE DESIGNERS

Although she's often seen wearing Gucci or Fendi, Gwyneth also experiments with lesser known designers like Ralph & Russo, David Koma, Galvan, and Adam Lippes. And, of course, she also wears clothes designed by her friend Stella McCartney.

HER 3 ICONIC LOOKS

Twenty years on, the Ralph Lauren dress she wore to accept her Oscar is still a fashion reference.

She has a penchant for minidresses with embroidery or a little twist that set her apart on the red carpet.

"My foolproof fashion fallback is jumpsuits. You don't have to think so much about your outfit."

GIGI HADID

Hooked on total look

BORN
**April 23, 1995,
Los Angeles,
California, US**

OCCUPATION
Model

DEFINING FEATURE
**Can pair the same
look with sneakers
or stilettos**

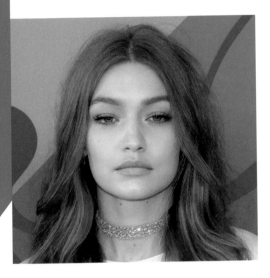

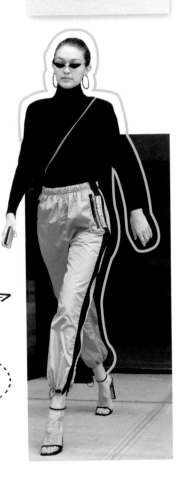

SHE IS FORTUNATE ENOUGH TO BE ABLE TO TRY ON COUNTLESS DIFFERENT GARMENTS EACH SEASON, BUT THE MODEL RESPECTS THE WORK OF DESIGNERS: SHE HAS A PREDILECTION FOR HEAD-TO-TOE ENSEMBLES.

HER ICONIC LOOK

Sweatpants. Miss Hadid wears them with high heels: sportswear is her thing.

GIGI'S
style secret

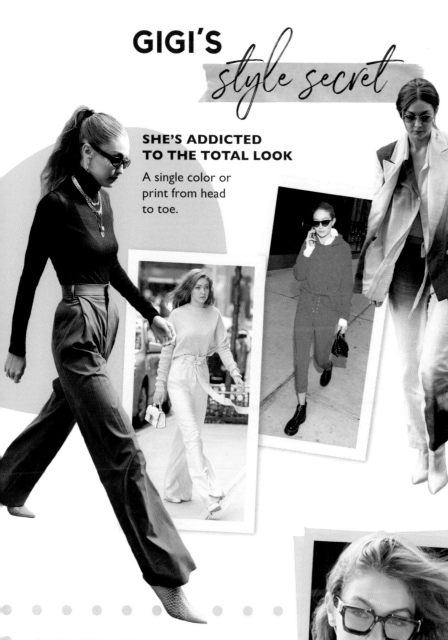

SHE'S ADDICTED TO THE TOTAL LOOK

A single color or print from head to toe.

HER KILLER DETAIL

Shades. "I own a lot of sunglasses, probably 200 pairs, or even more. And I actually wear all of them."

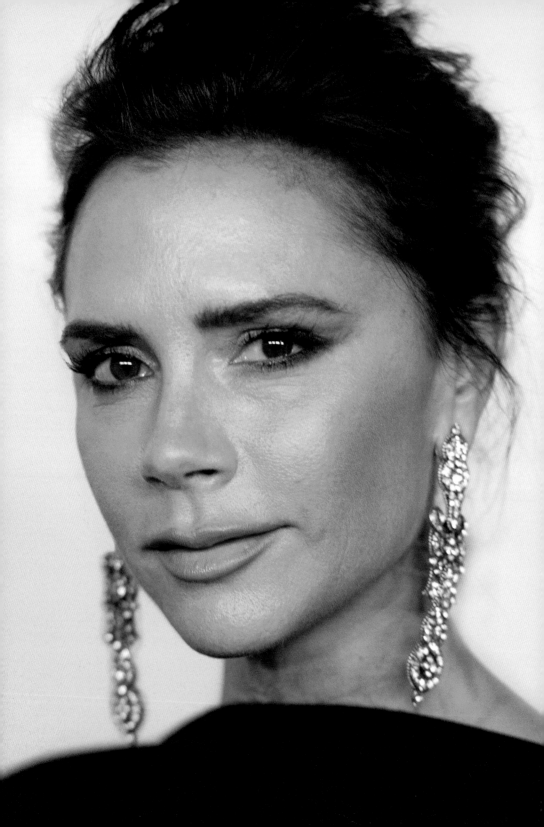

BORN
**April 17, 1974,
Harlow, UK**

OCCUPATION
**Fashion designer
and former singer**

DEFINING
FEATURE
**Never leaves home
without polishing
her look**

VICTORIA BECKHAM

Luxury posh

THINGS COULD HAVE TURNED OUT DIFFERENTLY, BUT THE FORMER SPICE GIRL SUCCESSFULLY ENTERED THE INNER CIRCLE OF STYLISH WOMEN. SHE ABANDONED HER INITIAL SEXY-BRIT LOOK AND DREW INSPIRATION FROM ONLY THE BEST DESIGNERS IN HER WARDROBE. THE RESULT IS A MASTERCLASS IN LUXURY STYLE.

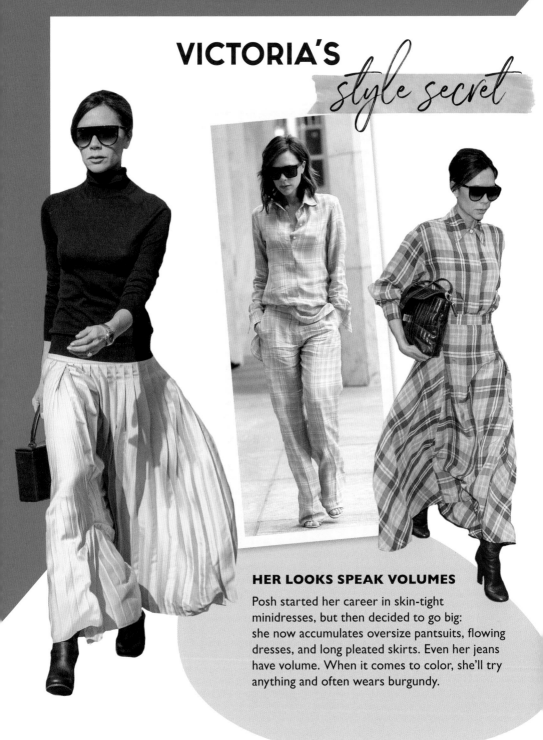

VICTORIA'S
style secret

HER LOOKS SPEAK VOLUMES

Posh started her career in skin-tight minidresses, but then decided to go big: she now accumulates oversize pantsuits, flowing dresses, and long pleated skirts. Even her jeans have volume. When it comes to color, she'll try anything and often wears burgundy.

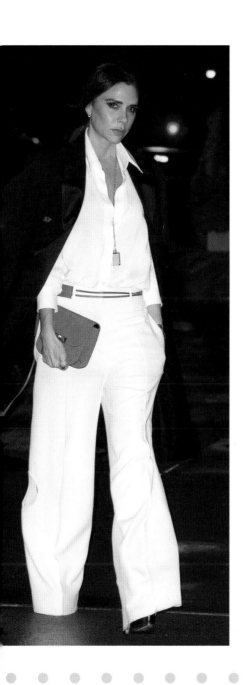

To build some fashion cred, she traded in her miniskirts for knee-length versions. And it worked! The British bombshell figured out that too much skin will kill a good style. As a hunky athlete's wife, Mrs. Beckham began her fashion career by flaunting logos and maxi-size rocks, but she found her current style when she started designing her own clothes, glasses, bags, and shoes. She's always immaculately polished yet creative: she doesn't easily give in to all-black and dares to mix unique colors (mauve and bright red, khaki and sky blue) and prints (she adores plaid). Regardless of the look, it always has to be luxe. The result is a posh British style that could serve as inspiration for career girls everywhere.

HER FAVORITE DESIGNERS

Roland Mouret's body-sculpting dresses drew attention to her style—in fact, they inspired her fashion brand. Today, Vic wears her own designs.

HER KILLER DETAIL

Victoria is never seen without her sunglasses. But the detail that really clinches her style is a penchant for coordinating her bag and shoes. The more unexpected the color, the better the result.

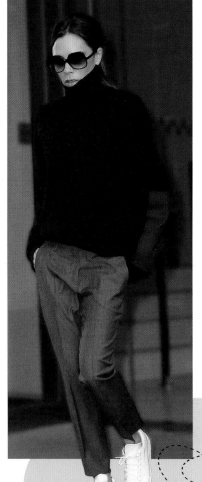

> **"** *It might seem a bit stupid, but the night before, I visualize the look I'd like to wear. I can never get ready quickly. And since I don't like to hurry, I plan ahead.* **"**

Victoria Beckham

STEAL THIS IDEA

You'll rarely catch Victoria wearing tennis shoes, but when she does, they look great combined with trousers and an oversize turtleneck sweater. It never hurts to relax.

HER 3 ICONIC LOOKS

A sweater, pencil skirt, clutch, and open-toed boots (a style Victoria loves) make it easy to look chic.

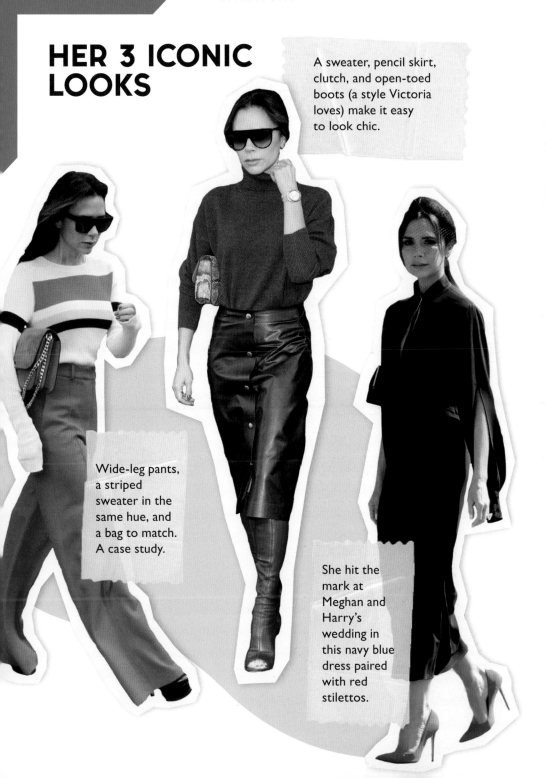

Wide-leg pants, a striped sweater in the same hue, and a bag to match. A case study.

She hit the mark at Meghan and Harry's wedding in this navy blue dress paired with red stilettos.

BORN
**April 9, 1990,
Los Angeles,
California, US**

OCCUPATION
Actress

DEFINING
FEATURE
Gender fluid

KRISTEN STEWART

Cool couture

WITH HER ANDROGYNOUS LOOK, KRISTEN STEWART MADE
HER MARK ON THE RED CARPET, WHERE BALL GOWNS
SEEMED TO BE THE ONLY FASHIONABLE OPTION. SHE CAN
WEAR ANYTHING—MINISKIRT, MINI-SHORTS, TROUSER SUIT,
EVEN A LONG DRESS—BUT ON HER OWN TERMS.

KRISTEN'S *style secret*

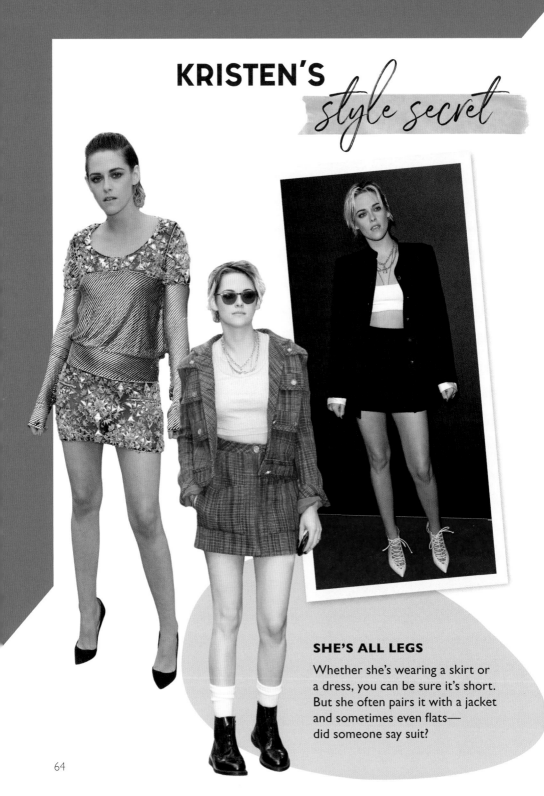

SHE'S ALL LEGS

Whether she's wearing a skirt or a dress, you can be sure it's short. But she often pairs it with a jacket and sometimes even flats— did someone say suit?

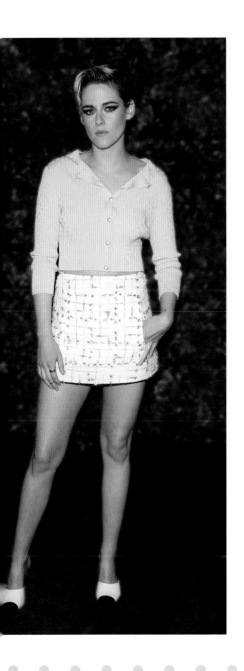

Kristen quickly mastered the red-carpet game and immediately let the world know where she stands: she'll never bow to fashion. When she climbs the steps at the Cannes Film Festival in uncomfortable stilettos, she takes them off and walks barefoot the rest of the way, then shows up in sneakers in the evening. A fashion victim? Not her. She moves smoothly from miniskirt to pantsuit, and from heels to sneakers. No one can put a label on her. She's more than a liberated woman: she's a woman who takes liberties as she pleases.

HER FAVORITE DESIGNERS

Balenciaga, Stella McCartney, Proenza Schouler, Thom Browne, Alessandra Rich, and Petar Petrov. Since 2013, she's been a muse for Chanel, proving that a tailored jacket can make many a look.

The baseball cap: she wears it with skirts and jeans. Her signature move? Turning it backwards.

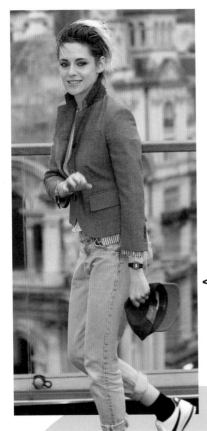

"To have style, it's really important to like what you're wearing."

Kristen Stewart

STEAL THIS IDEA

Cuffed jeans and a striped shirt under a well-cut jacket—but with very sporty sneakers and socks. She likes mixing styles.

HER 3 ICONIC LOOKS

How do you make a suit attractive? Kristen has figured it out: it's all about the color.

Shorts with a tailored jacket and flat lace-up boots: so Kristen—and so Chanel!

Sequined pants, an open shirt, and a satin collared jacket—that's a Stewart-style tuxedo.

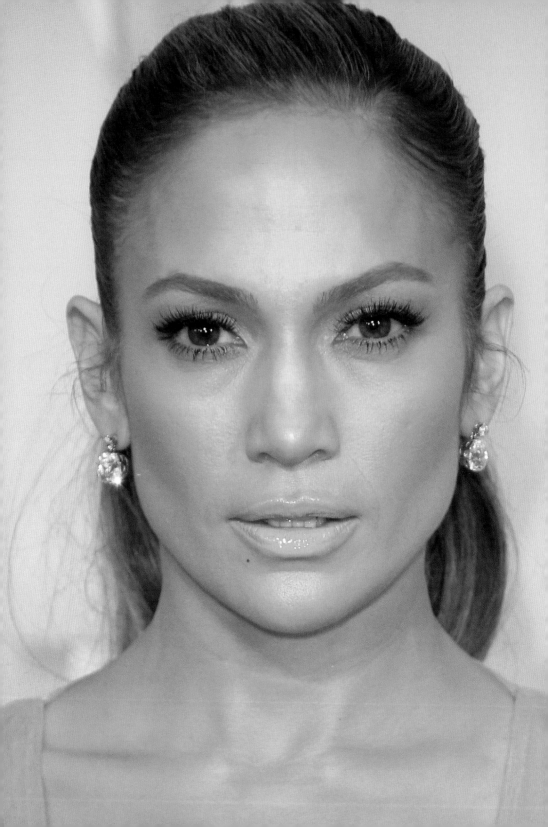

BORN
**July 24, 1969,
New York,
New York, US**

OCCUPATION
Singer and actress

DEFINING
FEATURE
Still sexy after fifty

JENNIFER LOPEZ

Street glam

GROWING UP IN THE BRONX, J.LO DREAMED OF 1950S HOLLYWOOD GLAMOUR. SHE STARTED HER CAREER IN SHOW BUSINESS WEARING 1990S STREET STYLE—THICK SOLES AND BIG GOLD HOOP EARRINGS—WHICH SHE SUCCESSFULLY COMBINED WITH HOLLYWOOD GLITTER.

JENNIFER'S *style secret*

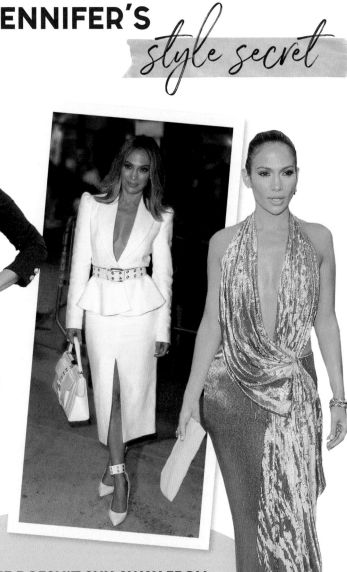

SHE DOESN'T SHY AWAY FROM PLUNGING NECKLINES

Ms. Lopez always showcases her femininity, whether she's wearing a suit jacket or a dress. She asserts her sensuality with narrow waists and high heels.

"*In the Bronx, we dressed like boys. It was very Latin, big hoops and eyeliner, and that stayed with me. That mix of toughness and sexiness.*"

Jennifer Lopez

HER KILLER DETAIL

Gold hoops, J.Lo's official earrings. She's worn them since the very beginning—they're a nod to her Latina heritage.

When J.Lo arrived from the Bronx with her crop tops and low-waist jeans, no one imagined she'd be strutting down Hollywood's red carpets in ultra-glamorous looks several years later. Like Victoria Beckham, she quickly adopted the tricks of the trade and is now a woman who—despite a few missteps with skin-tight sequined dresses—masters the luxe look.

HER FAVORITE DESIGNERS

In 2000, J.Lo captured the cameras on the red carpet in a Versace dress. The label holds a special place in her heart, and she modeled again for her friend Donatella in September 2019. Although she's a fan of Tom Ford and Valentino, J.Lo also chooses red carpet designers, like Georges Hobeika and Zuhair Murad, for her spectacular long evening dresses.

STEAL THIS IDEA

A touch of glitter. She's been known to sport the total look, but for something more subtle, she adds just a dash of sparkle— on a clutch, or a top or skirt.

HER 3 ICONIC LOOKS

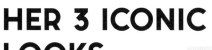

The famous green Versace dress she wore to the 2000 Grammy Awards. It doesn't get any sultrier than this.

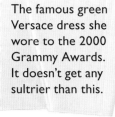

An oversize plaid jacket with thigh-high boots—flashy street style.

J.Lo goes for hushed luxury looks.

73

MARGOT ROBBIE

Understated

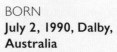

BORN
July 2, 1990, Dalby, Australia

OCCUPATION
Actress

DEFINING FEATURE
Rarely wears color

MARGOT EARNED A PLACE AMONG THE FASHION MUSES IN RECORD TIME. HER SECRET WEAPON: SHE OFTEN WEARS BLACK AND WHITE.

HER ICONIC LOOK

The lamé dress by Tom Ford that she wore to the Oscars in 2016 outshone the golden statuette.

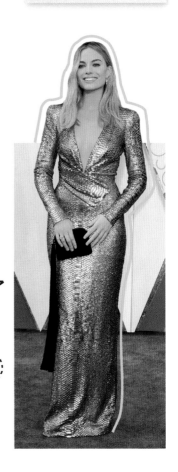

MARGOT'S

style secret

BLACK AND WHITE

Trousers, shirts, and dresses, both long and short: as the face of Chanel, she proudly flaunts the label's palette.

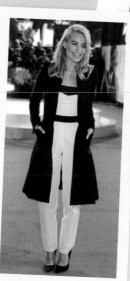

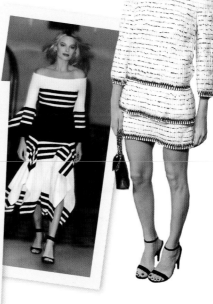

HER KILLER DETAIL

Wavy hair. Undulating locks soften her very graphic outfits.

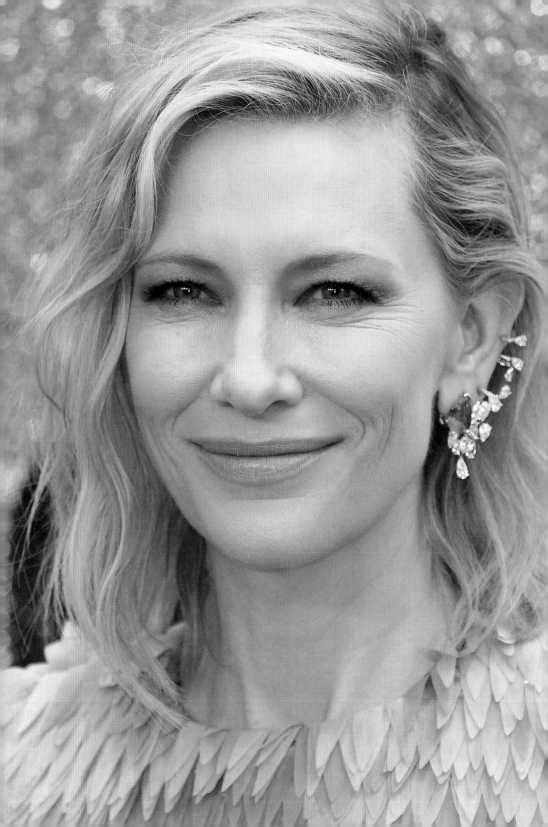

BORN
**May 14, 1969,
Melbourne,
Australia**

OCCUPATION
Actress

DEFINING
FEATURE
**Worships
the pantsuit**

CATE
BLANCHETT

Modern elegance

"STYLE SHOULD NOT BE TOO WORKED OR CONSCIOUS,
BECAUSE CONTROL IS THE ENEMY OF BEAUTY." FOR CATE
BLANCHETT, WE SHOULD NEVER BE SLAVES TO DOGMA.
BUT HER STYLE IS ANYTHING BUT BOTCHED. EQUAL PARTS
ELEGANCE AND IRREVERENCE, MS. BLANCHETT INVENTED
A NEW DEFINITION OF ALLURE.

CATE'S
style secret

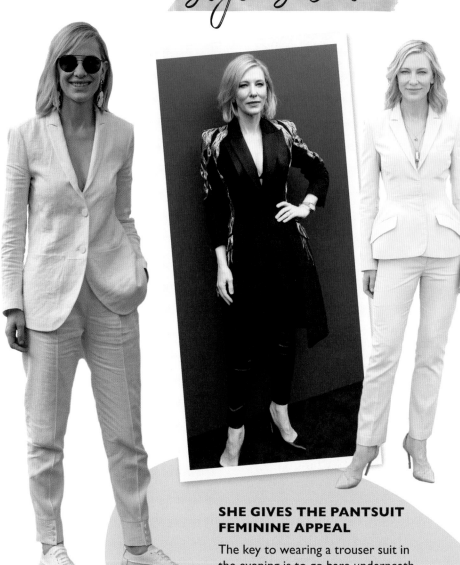

SHE GIVES THE PANTSUIT FEMININE APPEAL

The key to wearing a trouser suit in the evening is to go bare underneath. Yes, yes, even after fifty!

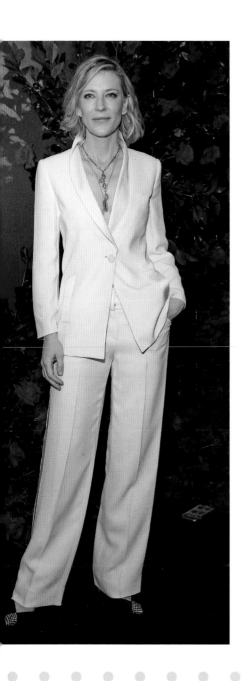

She made the pantsuit the symbol of intelligent elegance on the red carpet. Of course she's also been known to break out spectacular dresses with frills, asymmetrical cuts, pleats, and large bows. Nevertheless, she brought the woman's suit to the red carpet and gave it the same integrity as the formal gown, establishing equality between the garments. Who says a dress is more formal than a suit? When it comes to designers, Cate knows her ever-chic classics, but also has an eye for finding creative new talent. One of the secrets to staying in the fashion game is not settling for a single brand.

HER FAVORITE DESIGNERS

An ambassador for Giorgio Armani, she adores this designer who excels at mixing the masculine and feminine. She also enjoys trying out lesser known designers like Rokh, Sara Battaglia, and Monse.

HER KILLER DETAIL

A bob cut always ensures that you look elegant, even in jeans and a T-shirt.

*" Style evolves,
it adapts
to our lifestyle.
I like unique
people."*

Cate Blanchett

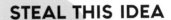

STEAL THIS IDEA

"Don't be afraid to break the rules," says Cate. She pairs a pink skirt suit with white sneakers—but no laces. The goal is to stay classy, after all.

HER 3 ICONIC LOOKS

A suit in an unexpected fabric: whether flecked, plaid, or even polka dot, patterns don't scare Cate.

A black velvet tuxedo is a safe bet for events where an evening gown would be overkill.

Black pants with a colorful shirt. Black loses its dramatic edge when paired with yellow. Perfect!

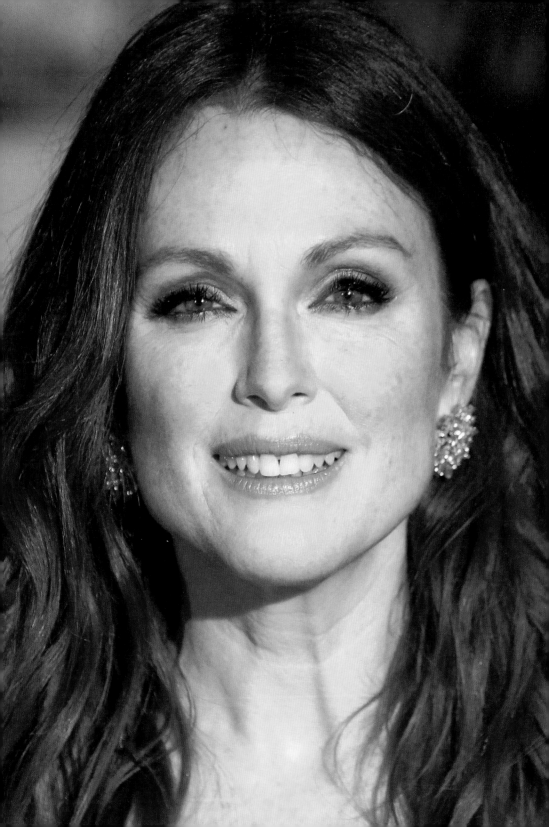

BORN
**December 3, 1960,
Fayetteville,
North Carolina, US**

OCCUPATION
Actress

DEFINING
FEATURE
**Switches up bright
colors with black
and white**

JULIANNE MOORE

Flamboyantly classic

THE ACTRESS SPORTS A CLASSIC STYLE THAT DRAWS
ATTENTION ON THE RED CARPET, WHERE SHE OPTS
FOR EYE-CATCHING DRESSES. BUT WE'RE INTERESTED
IN HER STREET STYLE, WHICH IS TIMELESS AND ALWAYS
EASY TO COPY.

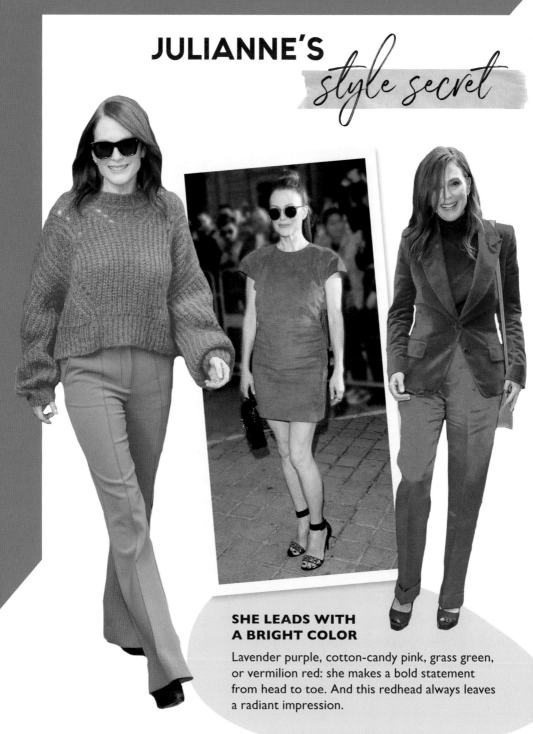

JULIANNE'S *style secret*

SHE LEADS WITH A BRIGHT COLOR

Lavender purple, cotton-candy pink, grass green, or vermilion red: she makes a bold statement from head to toe. And this redhead always leaves a radiant impression.

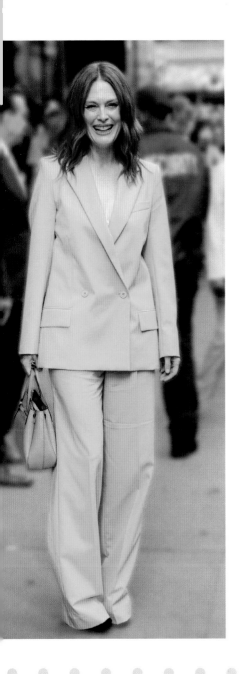

Julianne with her flaming red tresses likes to have fun with colors. She sports a multitude of eye-catching ensembles or outfits with creative details. She owns her flamboyant mane and brings a sense of joy to fashion. But for everyday wear, she prefers discretion and is at heart a "jeans and T-shirt" girl. She especially likes basics and rejects overconsumption. She's been known to curb her shopping to concentrate on what she has in her closet, getting rid of what she doesn't wear. "Not shopping is helping me to refine my taste, to consume less and more thoughtfully, and to avoid fast fashion," she explains.

HER FAVORITE DESIGNERS

Tom Ford, Givenchy, Louis Vuitton, Chanel, Christian Dior, Valentino: when it comes to the red carpet, Julianne turns to reliable classics. For daily wear, she goes for simple pieces— what's important for her is to wear timeless, logo-free basics that will last a lifetime.

HER KILLER DETAIL

A cross-body bag. Usually this style is reserved for daytime wear, but Julianne has no qualms about taking it to cocktail parties. It's much more practical than a clutch!

STEAL THIS IDEA

Off-duty, Ms. Moore often keeps a low profile in black and white. Sneakers, loose pants, and a T-shirt: she never complicates the look with one-off pieces. Staying chic also means staying simple.

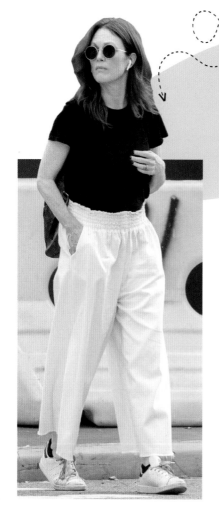

"I've always bought pretty classic stuff. When I intentionally go too trendy, I'm always really sorry because it doesn't suit me, and I don't wear it as often."

Julianne Moore

HER 3 ICONIC LOOKS

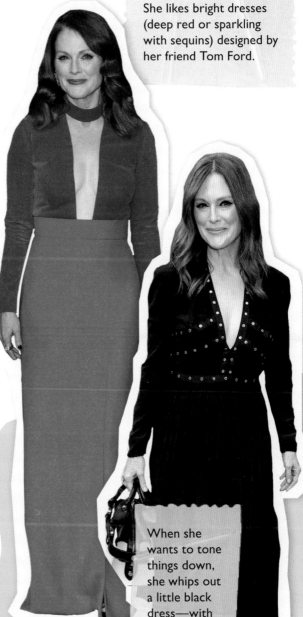

She likes bright dresses (deep red or sparkling with sequins) designed by her friend Tom Ford.

Military jacket, loose-fit jeans, Birkenstock sandals: this is Julianne's go-to casual daytime outfit.

When she wants to tone things down, she whips out a little black dress—with black boots.

BORN
**August 4, 1981,
Los Angeles,
California, US**

OCCUPATION
**Actress and
Duchess of Sussex**

DEFINING
FEATURE
**Quickly learned
to carry herself
like royalty**

MEGHAN MARKLE

High-class style

MEGHAN MARKLE SHOCKED THE WORLD WHEN SHE TURNED HER BACK ON THE ROYAL LIFE. BUT HER ARRIVAL IN LOS ANGELES AND OVERTURES FROM DISNEY PROMISE A VERY STYLISH FUTURE ON THE RED CARPET. ONCE SCRUTINIZED FOR HER EXPENSIVE OUTFITS, SHE'S NOW FREE TO DABBLE IN FASHION WITHOUT ANSWERING TO ANYONE.

MEGHAN'S

style secret

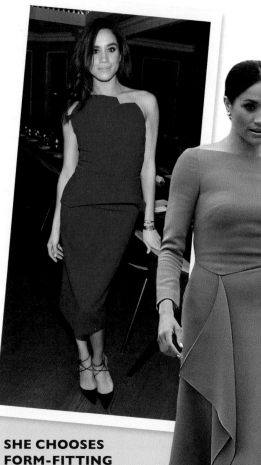

SHE CHOOSES FORM-FITTING DRESSES TO ACCENTUATE HER FABULOUS FIGURE

She also wore this look when she played the role of Rachel Zane in the series *Suits*.

"*When you invest in a great piece, you're going to pull it out of your closet again and again.*"

Meghan Markle

HER KILLER DETAIL

Whenever she wears a bag by a new designer (Strathberry pictured here), the "Meghan effect" strikes: it immediately goes out of stock.

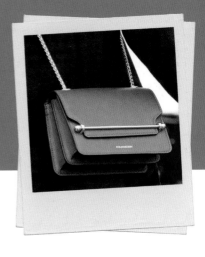

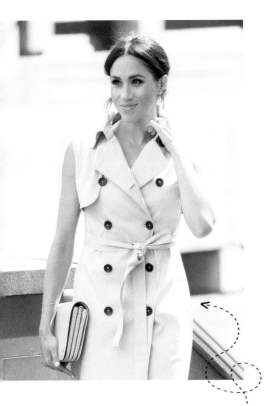

STEAL THIS IDEA

Coordinate your clutch or bag with your outfit. It always looks chic and there's no risk of clashing colors.

Before she met Prince Harry, Meghan was a no-fuss kind of girl who could do casting calls in jeans and a white button-down or, when the moment called for something more sophisticated, leather leggings and a blazer. From the moment she got engaged, she had to stay in line and respect a certain protocol, including no short dresses. Now that she's abandoned her royal position, one thing is for sure: she knows how to dress for any occasion—like any actress worth her salt.

HER FAVORITE DESIGNERS

A close friend of the designer Roland Mouret, she adores his creations, which she wore in *Suits*. She went with Givenchy for her wedding dress— perhaps as a nod to Audrey Hepburn, whose style she admires?

HER 3 ICONIC LOOKS

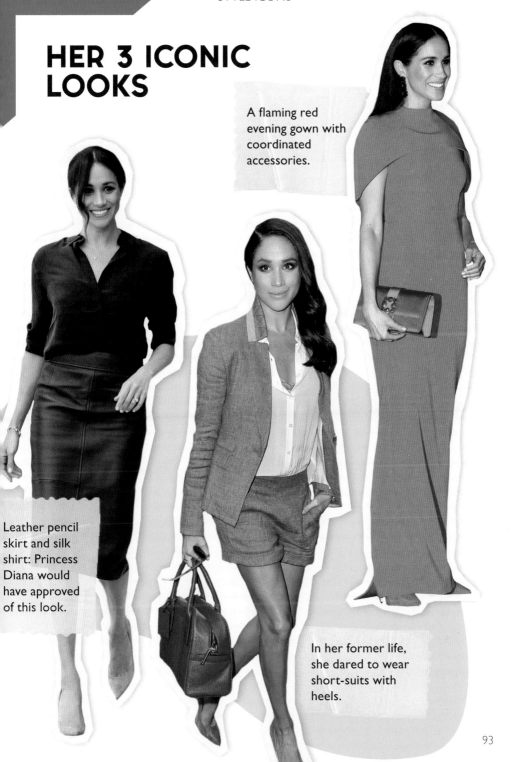

A flaming red evening gown with coordinated accessories.

Leather pencil skirt and silk shirt: Princess Diana would have approved of this look.

In her former life, she dared to wear short-suits with heels.

LIYA KEBEDE

African chic

BORN
**January 3, 1978,
Addis-Abeba,
Ethiopia**

OCCUPATION
**Model, actress,
and fashion designer**

DEFINING FEATURE
Rarely wears heels

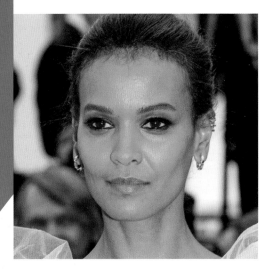

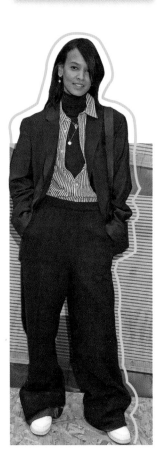

SHE CREATED THE BRAND LEMLEM TO HELP AFRICAN WOMEN BECOME SELF-SUFFICIENT AND TO PROMOTE THEIR CRAFT—PROOF THAT SHE HAS REAL STYLE.

HER ICONIC LOOK

Voluminous pieces are always a winner. In winter, she wears a thin turtleneck under a striped shirt with a suit.

LIYA'S
style secret

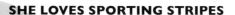

SHE LOVES SPORTING STRIPES

They define her Ethiopian-chic brand Lemlem. Miss Kebede found a way to apply these African lines to a couture skirt she designed for Moncler.

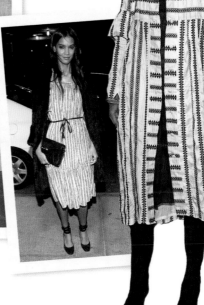

HER KILLER DETAIL

A cross-body bag—especially if it looks more like a luxury handbag than a satchel. Especially in the evening. She has a knack for reinvention.

SHE'S GOT THE LOOK

Habits forge a style. Wearing strictly black and white, oversize pieces, the total look, denim in every outfit, a jacket draped over the shoulders, or white heels to all evening events—the penchants of stylish women are multifarious. These personal touches are what make one stylista stand out from the fashion crowd. Find the quirk that suits you best from the signature looks of the women in this chapter, or make up your own (head-to-toe navy blue, flat boots, belting all your jackets—whatever you like) and go to town. That's how a style is born.

OLIVIA PALERMO
JACKETS DRAPED OVER SHOULDERS

Whether she's wearing a skirt, dress, or trousers, Olivia never puts her arms into her coat sleeves, which creates instant pizzazz. This also works with a cape.

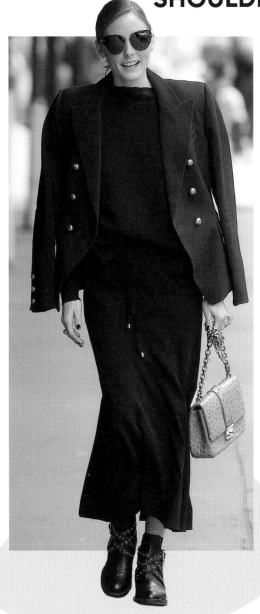

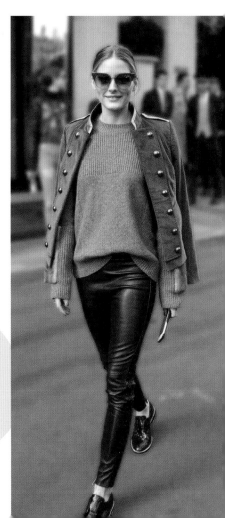

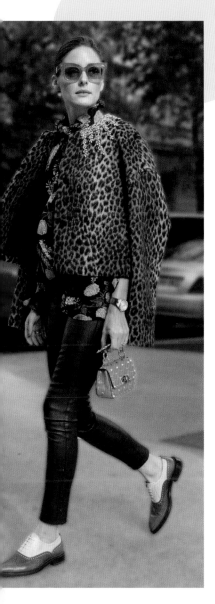

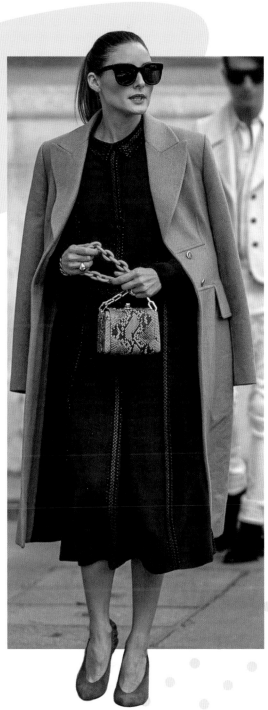

MILLIE BOBBY BROWN
FAIRYTALE DRESSES

Does the teen actress have a penchant for billowing dresses in soft shades because she started her career with a role in the series *Once Upon a Time in Wonderland*? One thing is certain: the young star of the series *Stranger Things* loves to pump up the volume as soon as a red carpet is in sight.

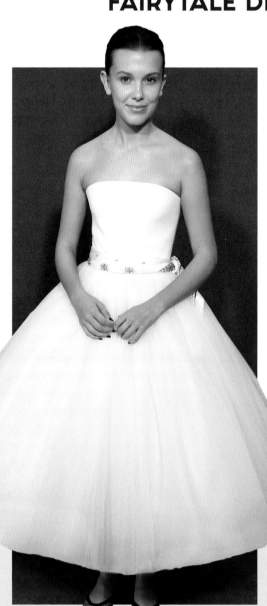

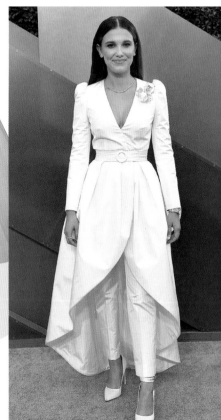

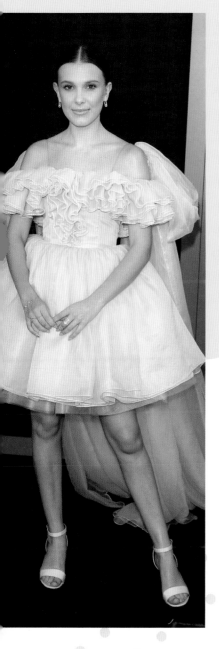

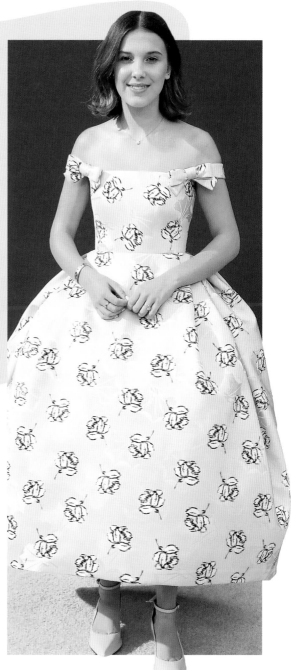

RIHANNA
WHITE MAGIC

The singer has always known that impeccable white draws the light. In a dress, skirt, or pants, she moves bewitchingly from romantic to seductive in the blink of an eye.

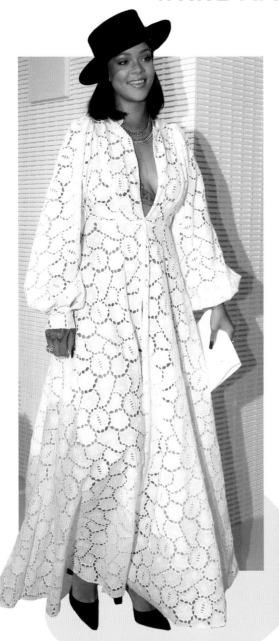

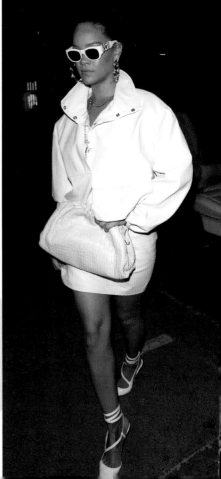

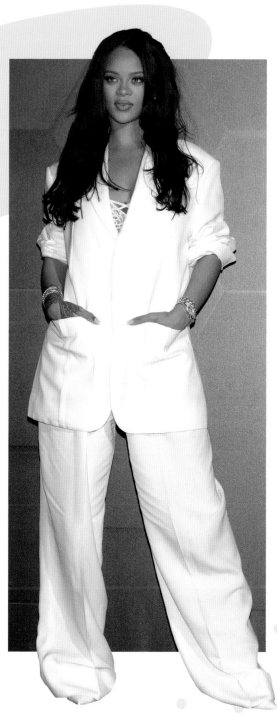
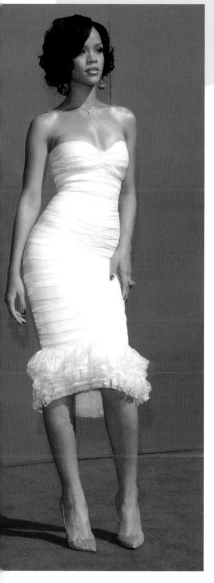

BILLIE EILISH
OVERSIZE OUTFITS

The young singer knows that you need a distinctive style to make it big. She found hers: oversize clothes and funky sunglasses. Gucci, Prada, or Valentino—she's always well branded.

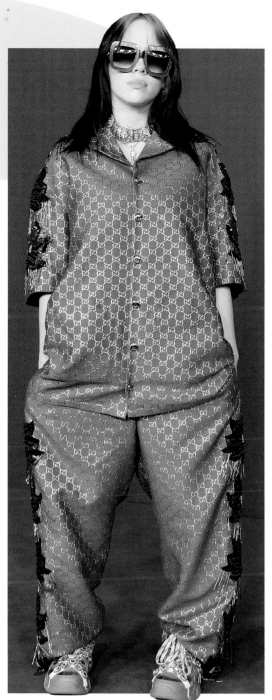

BRIGHT IDEAS BY ALEXA CHUNG

ONE OF THE FIRST "IT GIRLS" TO BUILD HER CAREER AROUND HER SARTORIAL STYLE, CHUNG WAS AN INFLUENCER BEFORE THE ERA OF INSTAGRAM. THE BRITISH MUSE, MODEL, AND TELEVISION HOST ALWAYS HAS PLENTY OF GOOD IDEAS TO TWEAK HER LOOK. TAKE WHAT YOU LIKE—THEY'RE ALL EASY TO COPY!

1 WEAR OVERALLS WITH A PLAID COAT

Alexa likes denim overalls, but looking childish is not her thing: a chic coat and vintage ankle boots add maturity to this ensemble.

2 PAIR LEOPARD-PRINT BOOTS WITH A BASIC LOOK

Gray turtleneck sweater, black coat, and jeans: the only way to make these spotted boots work is to wear them with an understated look.

3 COMBINE SILK AND VELVET

Mixing materials in shades of the same color is one of the easiest tricks for putting together an evening look without wearing a ball gown.

4 WEAR A COAT OVER A DELICATE DRESS

When you want to break out a gauzy dress with pleats and flowers, but summer is still around the corner, wear it under a warm plaid coat (yes, you have to be bold). If you dare, pair it with patent leather cowboy boots.

5 SOFTEN A MILITARY LOOK WITH GLAM BOOTS

She likes to add a little sparkle to basic pieces, like pairing a khaki bomber jacket and raw denim jeans with rhinestone ankle boots.

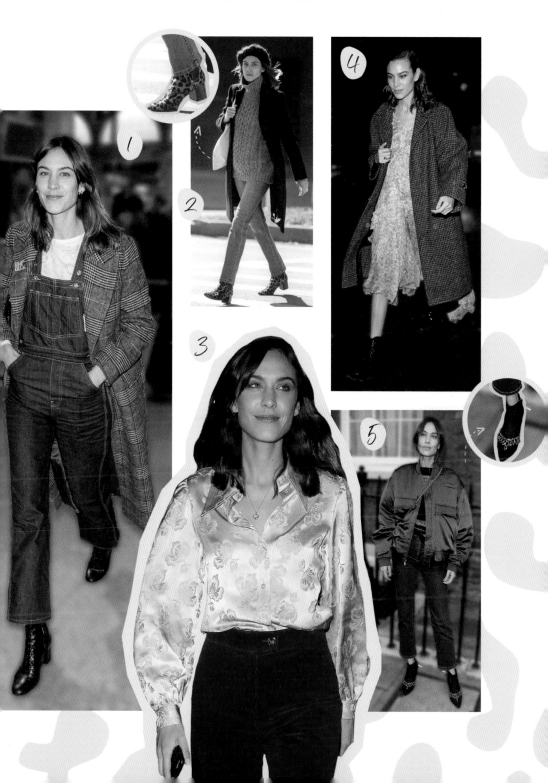

KAIA GERBER
BLACK SNEAKERS WITH WHITE LACES

The young supermodel has worn Converse sneakers from her very earliest appearances. Time marches on, but these cool shoes remain a staple in her wardrobe. She's just as likely to wear them with a floral print skirt as she is with jeans or sweatpants. Simple. Basic.

BLAKE LIVELY
DESIGNER ENSEMBLES

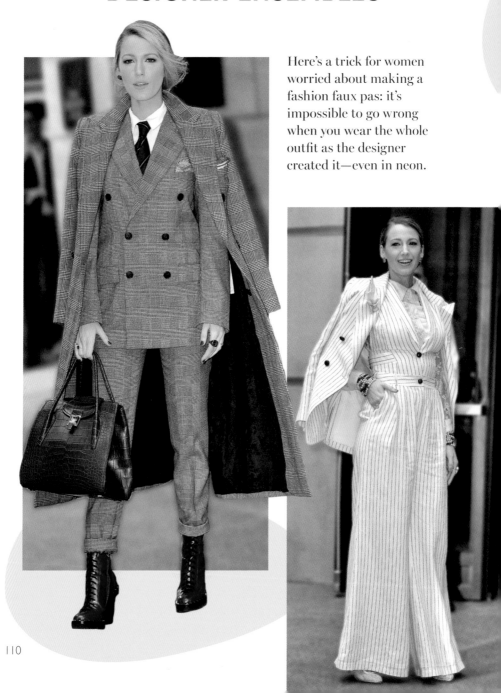

Here's a trick for women worried about making a fashion faux pas: it's impossible to go wrong when you wear the whole outfit as the designer created it—even in neon.

ASHLEY GRAHAM
CROP TOPS

This American supermodel found the look that showcases her shape: a high-waisted skirt or pants with a crop top. Often in heels, Ashley proves that you can show some skin and still be dressed up.

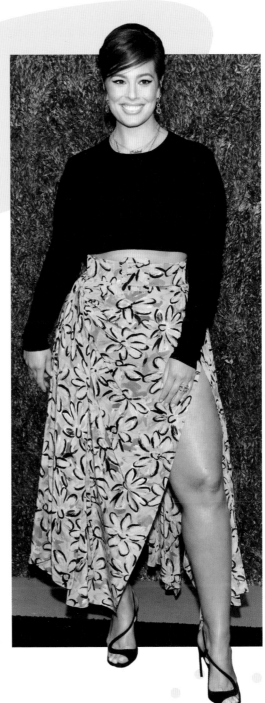

KIM KARDASHIAN
"SECOND SKIN" DRESSES

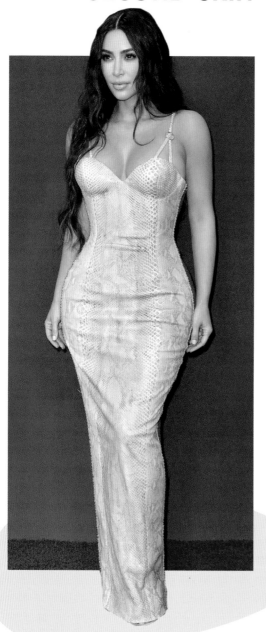

Kim's feminine style choice is clear: she celebrates her curves. Her long, form-fitting dresses show them off to perfection. Here's a woman who truly owns her sensuality.

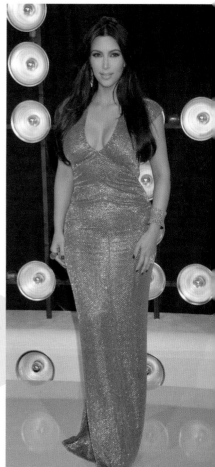

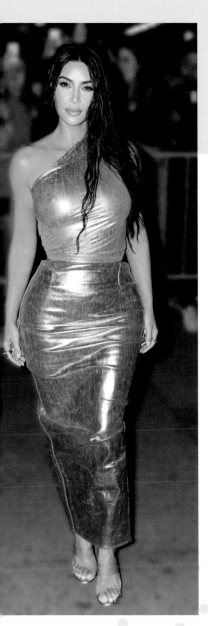

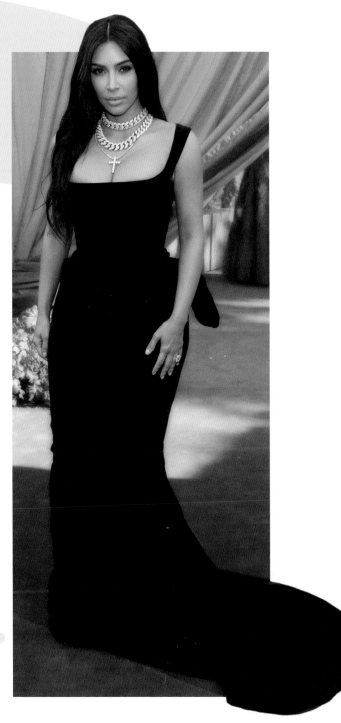

BRIGHT IDEAS BY BELLA HADID

BELLA CHANGES HER LOOK AS OFTEN AS SHE BRUSHES HER TEETH. "IT'S IMPOSSIBLE TO DEFINE MY STYLE," SHE SAYS. "IT CHANGES ALL THE TIME. I'VE REALIZED ONE IMPORTANT THING: IN FASHION, YOU HAVE TO BE BOLD, TAKE RISKS, EXPERIMENT, TO FINALLY FIND YOURSELF." MISS HADID DOESN'T LIMIT HERSELF TO A SINGLE STYLE, BUT SHE DOES FOLLOW SOME RULES.

1 TRY OFF COLORS

She manages to pull together a look with olive green pants, an almond green vintage jacket, a cropped white T-shirt, and white sneakers. She's not afraid of mixing it up.

2 SHAKE UP CHIC WITH SPORTSWEAR

A black pantsuit with a white tank top is too tame for her: she adds sporty, but sober, sneakers. Hoop earrings add a feminine touch that changes everything.

3 REINVENT CLASSICS

Take the Lacoste polo shirt: she opts for a diamond print and buttons the collar. But she's not about to play tennis—she pairs hers with leather pants and heels.

4 MIX GYM WEAR WITH LUXURY

Sportswear or stylish outfit? Either way, combining shorts with a Lycra bra top, a graphic shirt, and branded luggage will instantly create a presence.

5 ELEVATE THE DOWN JACKET

Just because the down jacket has an actual purpose (to keep you warm), it doesn't mean you should only wear it when it's cold out and with sportswear. Her printed version looks like contemporary art. How does she make it look stylish? By wearing pants in a coordinating color.

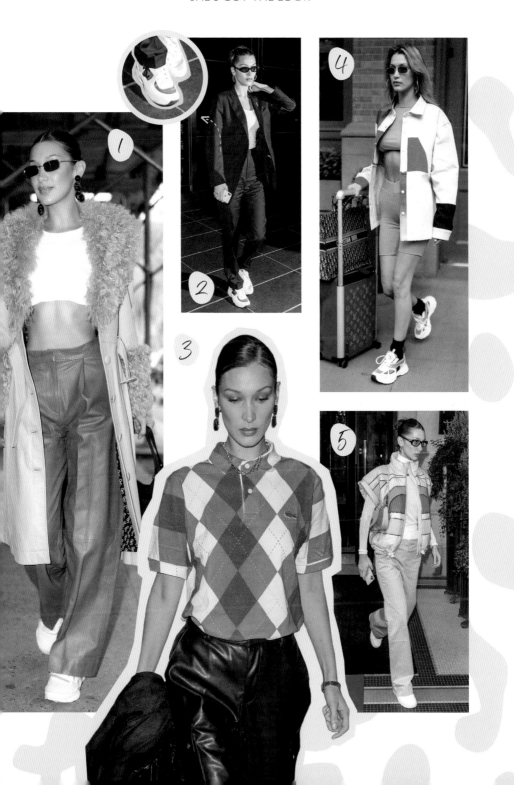

KATIE HOLMES
DENIM DETAILS

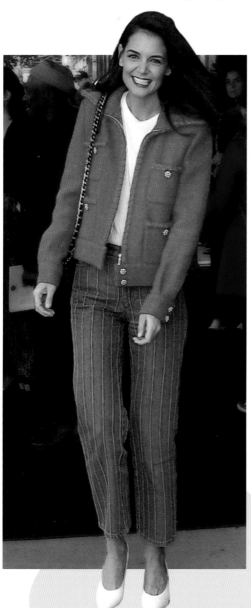

It's rare to see Katie without a touch of denim. It could be a skirt, jeans, or a jacket: the American actress includes denim in all of her looks. Pants paired with a couture jacket or a designer sweater, a skirt with a T-shirt and a lady's handbag, or a jacket over a striped dress: she knows indigo.

JANELLE MONÁE
GRAPHIC EFFECTS

Mixing black and white is a well-known trick among women who want to leave an impression without making too much noise. Neo-soul diva Janelle goes for graphic, very eccentric-chic outfits.

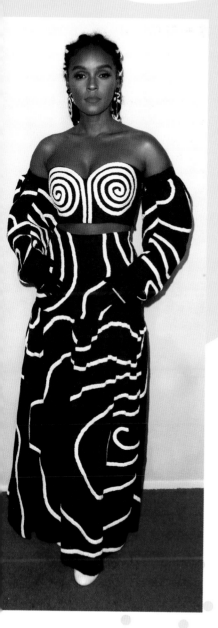

LIU WEN
JEANS + SNEAKERS

When she's traveling, supermodel Liu Wen always flies in uniform: jeans (usually loose) and sneakers. The rest depends on her mood. If she's feeling upbeat, she'll slip on a patterned sweater or colorful cardigan; for something more serious, she grabs a large, mustard yellow top.

ELLIE BAMBER
FLOWERY DRESSES

Ellie considers Chanel family. When she goes out in the evening, the English actress always opts for a flowery dress. And she's right: floral patterns create instant poetry.

BRIGHT IDEAS BY KARLIE KLOSS

A SUPERMODEL IS BOUND TO BE AN EXPERT AT BUILDING A STYLE. KARLIE IS IN CONSTANT CONTACT WITH DESIGNERS AND HAS CAREFULLY NOTED THEIR TIPS AND TRICKS TO CREATE HER TERRIFIC STYLE. HERE'S HOW.

1 MIX PINKS

A little bubble-gum pink sweater with a shocking pink skirt and coordinating shoes: together, these two shades create instant cheer—and they give her a radiant complexion.

2 GO FOR SHOWY SHOES

When you tend to wear dark colors, brighten things up with accessories. Her black bag is too ordinary, but her red shoes illuminate her look.

3 SEND A MESSAGE

"Sisterhood is global," the title of the feminist anthology by Robin Morgan, inscribed on her white T-shirt, gives meaning to her denim jacket and black pants: having style also means having something to say.

4 SHAKE UP THE BASICS

A fan of basic pieces, Miss Kloss doesn't fall into the all-black trap. A red blazer has her looking like a style pro—even with jeans and a T-shirt.

5 WORK WITH ONE TONE

When you dabble in pastels, you can mix and match, especially if they're nearly identical shades. The result creates a unified look without being bland.

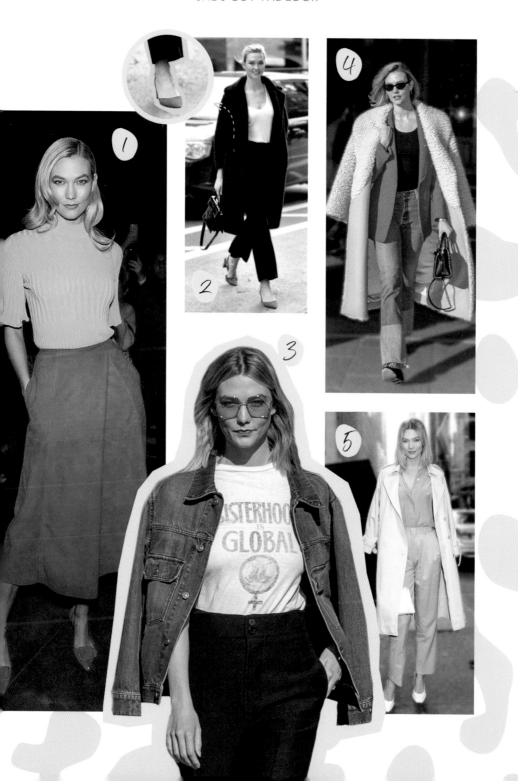

KATE BOSWORTH
MINIDRESSES + ANKLE BOOTS

The American actress and model always appears in fashion mode. Off the red carpet, she has a little quirk that's easy to copy and gives instant style: when she wears a minidress, she pairs it with ankle boots. Guaranteed to look modern.

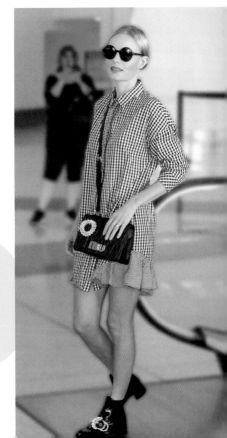

YARA SHAHIDI
MATCHING ENSEMBLES

This actress isn't interested in shaking things up: she's an expert in designer-led looks. She sticks to a theme with pants and a matching jacket or shirt. She's chic no matter what the color or print. It pays to stick to your principles.

JENNIFER CONNELLY
MINISKIRTS

She isn't one to change her fashion habits. Addicted to miniskirts and minidresses designed by Nicolas Ghesquière for Louis Vuitton, the actress never misses an opportunity to show off her slender legs. She's living proof that age is just a number.

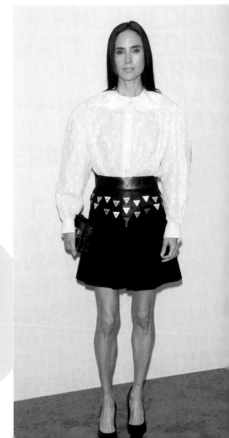

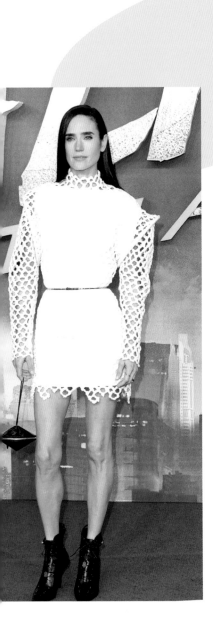

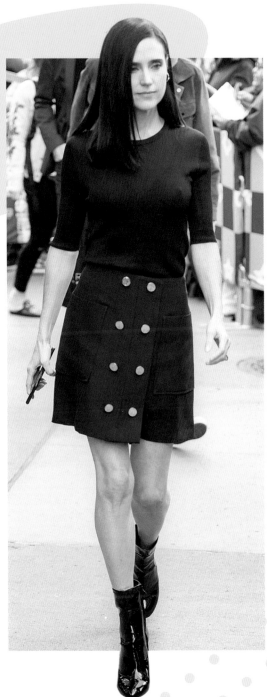

ZENDAYA
WHITE HEELS

This actress started out in series on the Disney Channel, and she loves cheerful, creative outfits. She wears white heels with bright colors or eye-popping embellishments—her secret for toning things down.

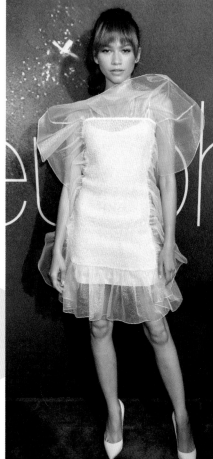

BRIGHT IDEAS BY EMMA STONE

COOL AND GLAMOROUS: THESE TWO TERMS DON'T USUALLY GO TOGETHER, BUT THAT'S WHAT EMMA'S OUTFITS BRING TO MIND. HOW DOES SHE MANAGE TO MIX CASUAL AND SOPHISTICATED? BY FOLLOWING THESE FIVE TIPS.

1 SHINE IN EVENINGWEAR

When she wants to leave an impression, she goes for glitter in the evening. Brocade, sequins, lamé: nothing is too sparkly for her.

2 WEAR A CAMISOLE

When it's hot out but a dress won't cut it. With a camisole (look in the lingerie section), simple black pants, a clutch, and heeled sandals, you've got yourself a sophisticated look without overdoing it.

3 DARE TO MIX RED AND PINK

The lovely redhead isn't afraid to mix so-called clashing colors: she wears a red satin blazer with a pink belt— paired with black pants, of course.

4 PAIR A BASEBALL CAP WITH A PLEATED SKIRT

An all-American favorite—and it works! A cap with a bronze pleated skirt, blazer, and high heels is a guaranteed home run.

5 WEAR A COAT AS A DRESS

Emma is a fan of Nicolas Ghesquière, artistic director at Louis Vuitton, and she likes wearing the brand's clothing. When a coat becomes a dress, she adopts the style.

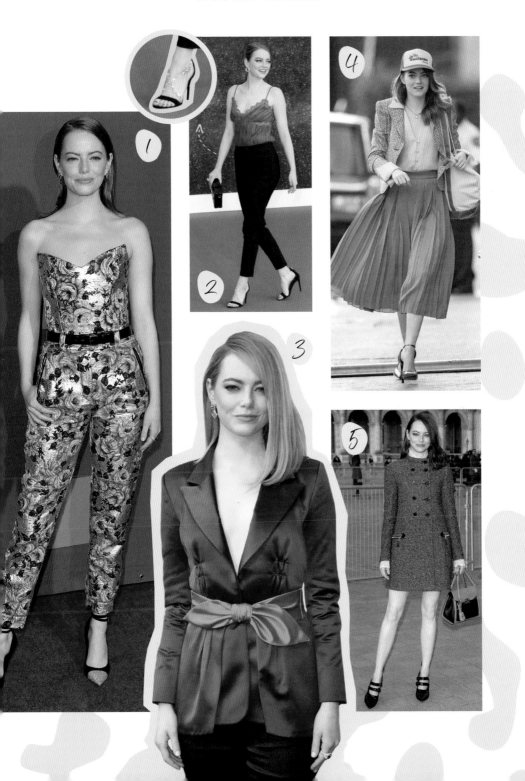

VANESSA PARADIS
ANKLE-LENGTH SKIRTS

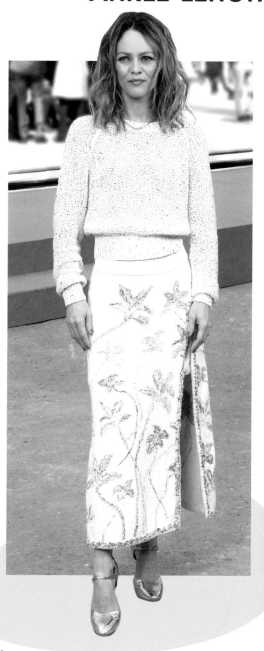

She was just nineteen when the singer and actress captured the spirit of Chanel, becoming the face for Coco perfume. She grew up with the brand's style. Today she carries on her legacy in a wardrobe of ankle-length skirts and dresses.

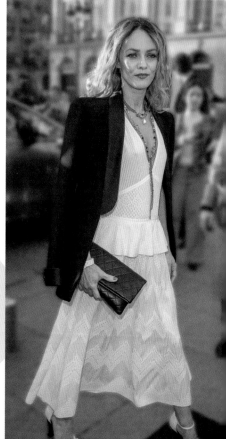

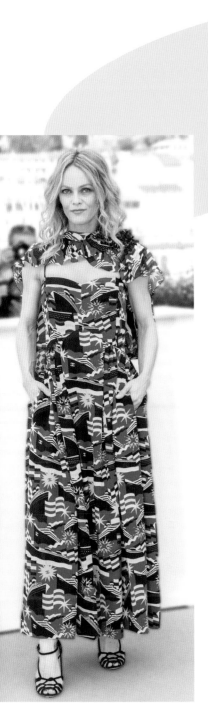

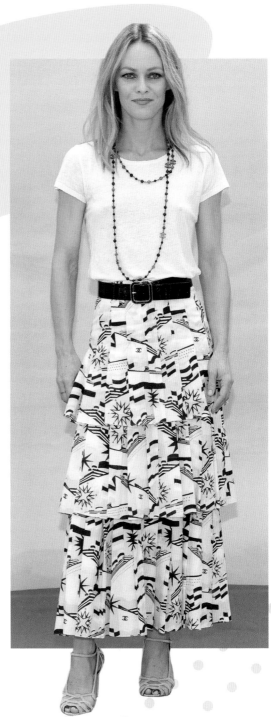

ANGELINA JOLIE
STRAPLESS DRESSES

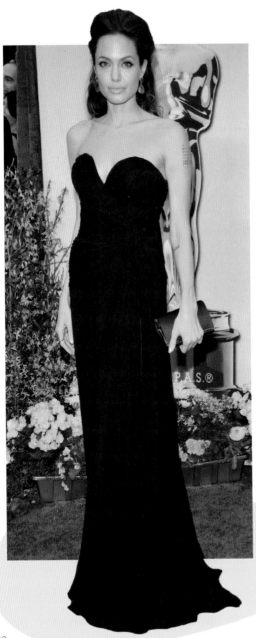

Angelina Jolie doesn't worry much about everyday wear and generally sticks to black. Her simple pieces keep her from making any fashion faux pas. On the red carpet, however, she has her little obsession: she has a large collection of strapless dresses, which also tend to be black, a color that always adds depth.

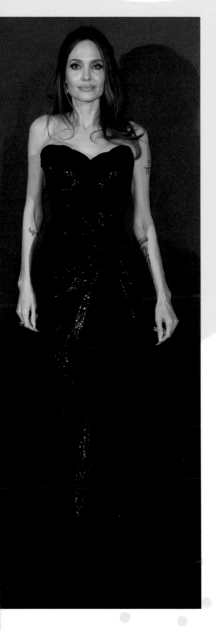

CÉLINE DION
DESIGNER TOTAL LOOK

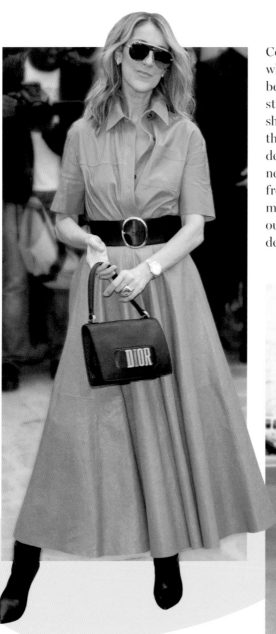

Céline is one of the few VIPs who makes no distinction between the stage and the street. Whenever she goes out, she wears looks straight from the runway. Respecting designers' wishes to a T, she never separates a print top from its bottom, and never mixes labels to create a funky outfit. She's totally devoted to designers.

RUTH WILSON
BELTED DRESSES

Known for her roles in the television series *Luther* and *The Affair*, the English actress has a predilection that creates instant style: belting her dresses. If you like a dress's fabric and color, but not the cut, adding a belt can make it work.

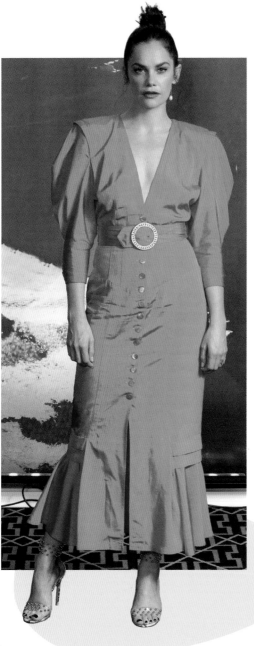

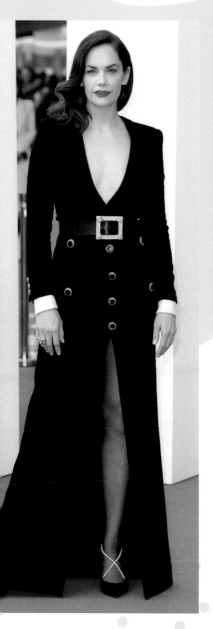

BRIGHT IDEAS BY LOU DOILLON

THE SINGER IS THE QUINTESSENTIAL WOMAN WITH A PERSONAL STYLE. LOU CREATED HERS ENTIRELY FROM SCRATCH. "I LOVE WEARING CLOTHES THAT CAPTIVATE ME, AND THAT ARE ALSO REFERENCES, LIKE THE BOOTS OF THOMAS HARDY'S HEROINE TESS OF THE D'URBERVILLES." HERE ARE A FEW THINGS THAT MAKE LOU'S STYLE UNIQUE.

1 DON'T BEND TO THE SEASONS

She can combine a (fake) fur coat and cropped jeans that reveal her lace-up boots. According to Lou, you don't ever need to cover up, even in winter.

2 COMBINE ROCK AND LUXURY

How do you pull off an iridescent frilly shirt without looking garish? By pairing it with a black leather skirt. Studded sandals are not mandatory, but they reinforce the idea that you can be a shiny happy rebel.

3 BRIGHTEN UP BLACK

This is the bright solution used by women who love the total black look: add a gold accessory (belt, boots, or bag) to avoid looking like a crow. Note Lou's smile: that's a detail that will always be in style.

4 ADD A BIT OF POETRY

An embroidered velvet jacket, a white shirt, jeans, and loafers: this is the poetic-romantic-couture style of the artist, who always has something to say. This look is easy to steal and immediately evokes a little je ne sais quoi.

5 DON'T BE AFRAID OF EXTREMES

Only Lou could wear these extra-large bell-bottoms with a gold necklace and a thick knitted sweater. She never asks herself questions like, "Does this go together?" If she likes it, she wears it.

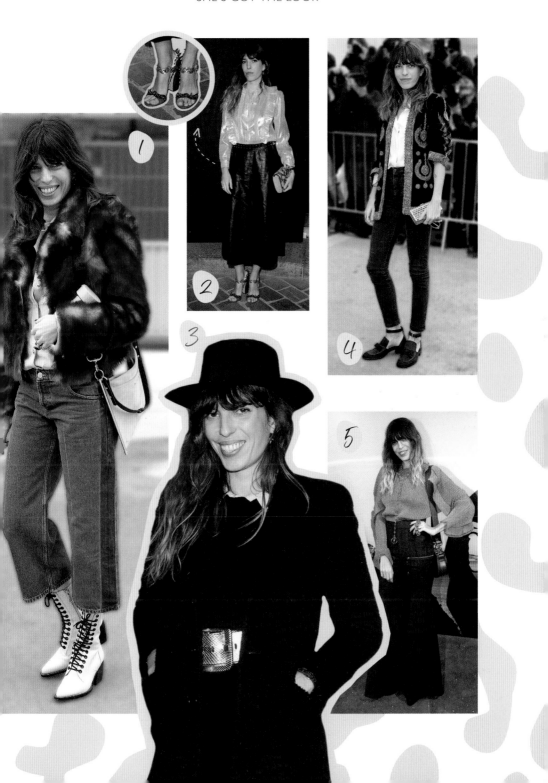

1

2

3

4

5

HOW TO WEAR STYLE ESSENTIALS

What essential pieces should be found in every wardrobe? The question comes up each season, when you're organizing your closet and you think, "I have absolutely nothing to wear." Ultimately, having a set of wardrobe basics is every fashionista's secret. You might think some women have enormous closets, when it's actually their way of mixing and matching that makes them stylistas. Everyone should learn the different ways to wear a trench coat, because a good one can last a lifetime: you just have to know how to make the most of it. Turtleneck, white shirt, jeans, or tuxedo jacket: make a note of these must-have pieces in order to create your style, and pay attention to how they're worn to avoid looking too plain.

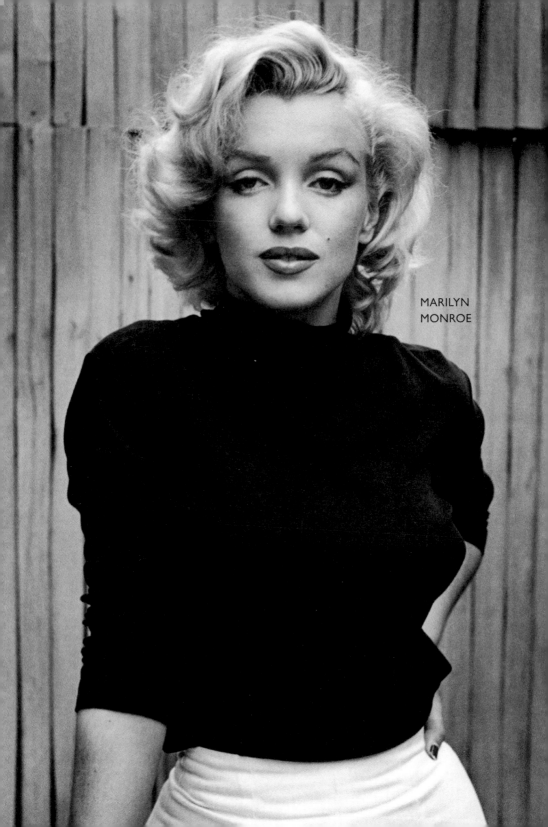

MARILYN
MONROE

TURTLENECK

THIS IS ONE OF THOSE GARMENTS THAT WOMEN STOLE
FROM MEN TO ASSERT THEIR EQUALITY. IN THE 1950S,
MARILYN MONROE PROVED THAT YOU COULD BE
SEDUCTIVE IN THIS SWEATER, WHICH, DESPITE THE
HIGHEST OF NECKLINES, CAN BE PRETTY FORM-FITTING.
IT'S A TRUE FRIEND WHEN TEMPERATURES DROP.
YOU NEED AT LEAST ONE FOR STYLE SAVVY.

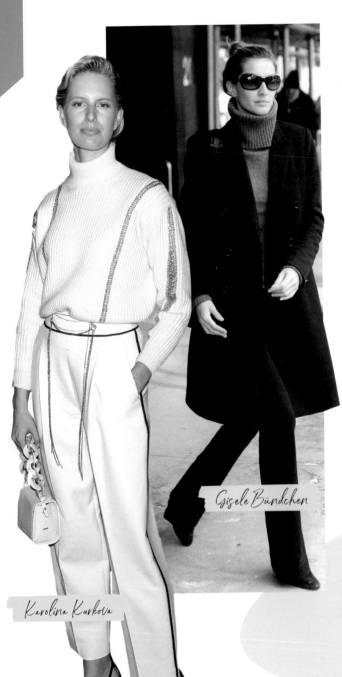

Gisele Bündchen

Karolina Kurkova

KAROLINA KURKOVA: PANTS AND TURTLENECK

Who said you can't wear a turtleneck for a night out? The Czech model's look is proof that if your sweater matches your trousers, and you wear it tucked in and with high heels, it can be very glam indeed.

GISELE BÜNDCHEN: A TOUCH OF GRAY

When worn with head-to-toe black, Gisele's gray sweater remains discreet while adding a lighter touch to this very sober style.

HEIDI KLUM: MAXI FORMAT

Don't hesitate to pair an oversize sweater with a cozy coat in the height of winter.

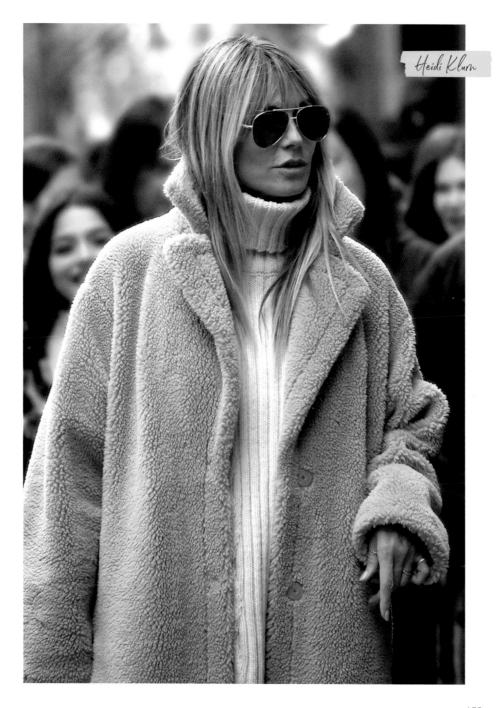

Heidi Klum

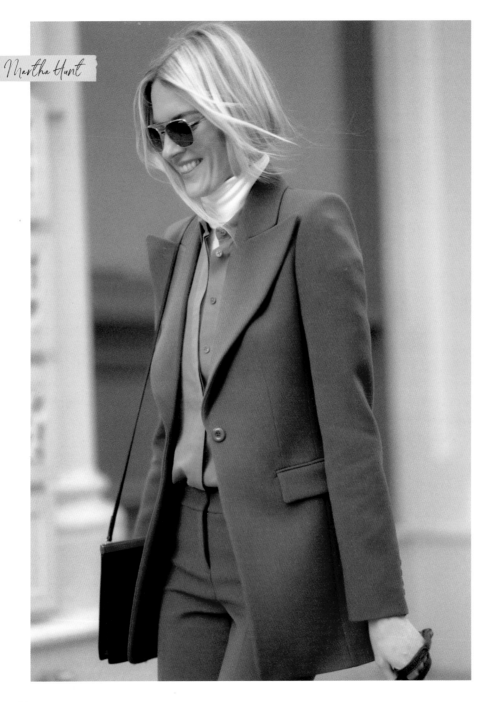

Martha Hunt

MARTHA HUNT: TURTLENECK BASE LAYER

A thin white turtleneck is perfectly professional when worn under a colorful button-down shirt and pantsuit.

ZOEY DEUTCH: ALL BLACK

Head-to-toe black? That's not very creative. To give a black sweater some zing, pair it with a beige coat and matching boots (in this case, UGGS). Elevate the look with a gold chain bag.

KENDALL JENNER: CROP TOP

When the temperature rises, don't take off your turtleneck—just shorten it. Remember this tip: wear a flashy sweater under an unbuttoned black shirt.

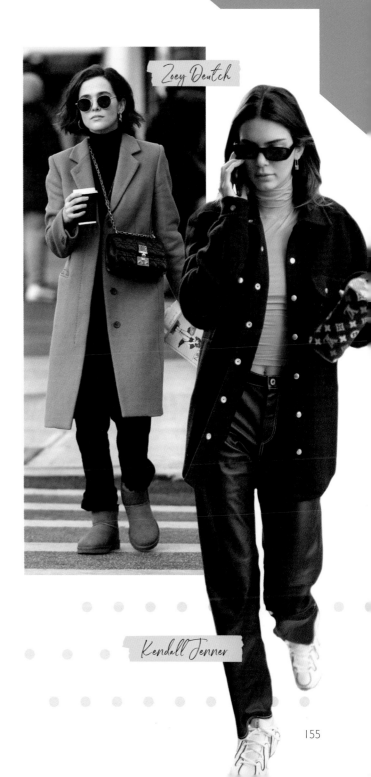

Zoey Deutch

Kendall Jenner

LAUREN
BACALL

WHITE SHIRT

LIKE THE WHITE T-SHIRT, THE CRISP, WHITE BLOUSE IS A NEUTRAL BUT ESSENTIAL ELEMENT TO BUILD A STYLE. IT ALLOWS US TO WEAR WARDROBE PIECES THAT OTHERWISE NEED TO BE "TAMED" TO LOOK THEIR BEST. THE WHITE SHIRT HAS THIS POWER: IT ADDS ELEGANCE WITHOUT DRAWING ATTENTION TO ITSELF.

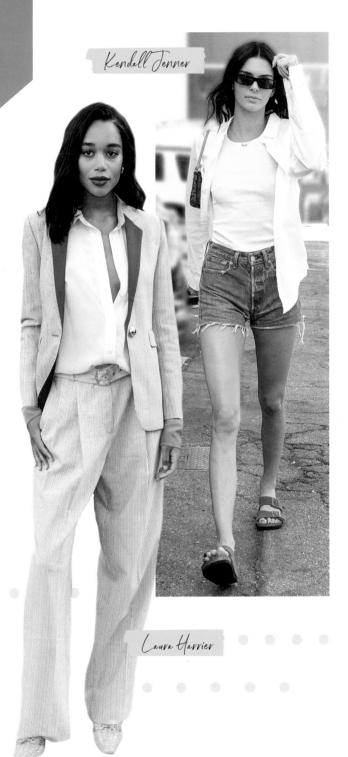

Kendall Jenner

Laura Harrier

LAURA HARRIER: ALL-TERRAIN

What works with an almond green blazer, pale pink pants, and yellow shoes? Only a white shirt will do!

KENDALL JENNER: AS A "JACKET"

Denim shorts and a white T-shirt—does that seem too predictable to you? Wear a white button-down shirt open like a jacket for a more grown-up look.

DOUTZEN KROES: GLEAMING

The white shirt stands out when worn with a colorful blazer and bag. Coordinating glasses make for an on-trend look.

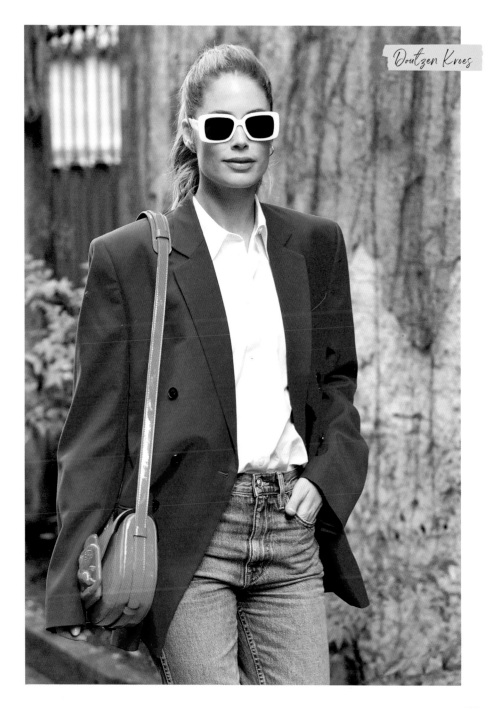

Doutzen Kroes

Kelsey Scott

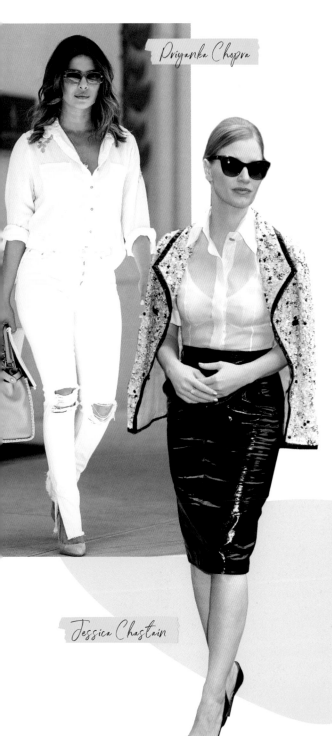

Priyanka Chopra

Jessica Chastain

KELSEY SCOTT: FLOWER POWER

It's not easy to wear flowery pants—they definitely make a statement. Kelsey can count on a gauzy white blouse to save this fashion foray.

PRIYANKA CHOPRA: LUXURIOUS

If you add a luxury brand handbag and high heels, the simple white shirt can be paired with torn jeans, without looking unkempt.

JESSICA CHASTAIN: SEXY

When the white shirt goes transparent, it drops its serious side and may even get a bit sassy, combined with a vinyl skirt and vampy heels.

VERONICA LAKE
In Paramount Pictures

WHITE T-SHIRT

THE TEXTBOOK WARDROBE BASIC: YOU CAN'T GET MORE NEUTRAL THAN THIS FORMER UNDERSHIRT WORN BY AMERICAN SOLDIERS AND MADE FAMOUS BY JAMES DEAN IN *REBEL WITHOUT A CAUSE*. CONSIDERED THE BLANK SLATE OF ANY LOOK, IT HAS A REPUTATION FOR COOL, BUT TIES IN WELL WITH LUXURY ENSEMBLES.

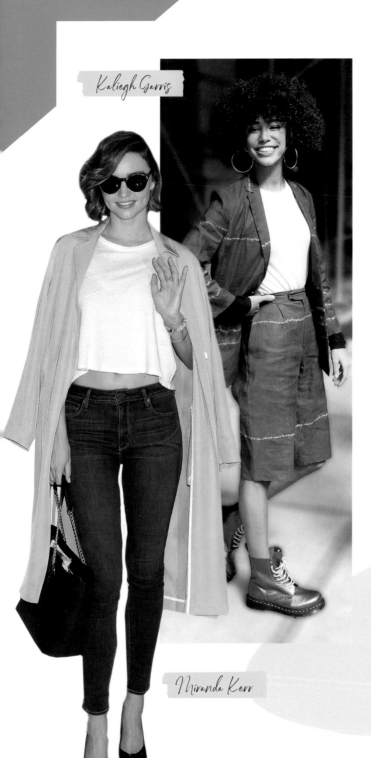

Kaliegh Garris

Miranda Kerr

MIRANDA KERR: THE CROPPED T-SHIRT

To avoid the "been there, done that" look of jeans and a T-shirt, cut your basic T into a crop top. Don't worry if the cut isn't straight—it will add even more cachet.

KALIEGH GARRIS: ON-TREND

When an indigo Bermuda-suit is worn with iridescent boots, a white T-shirt is more or less mandatory to finish the look while avoiding an overdose of statement pieces.

CARA DELEVINGNE: REFINED

Not entirely basic, Cara's thin-ribbed version proves she's not the type to look starchy in a suit (especially one in lilac).

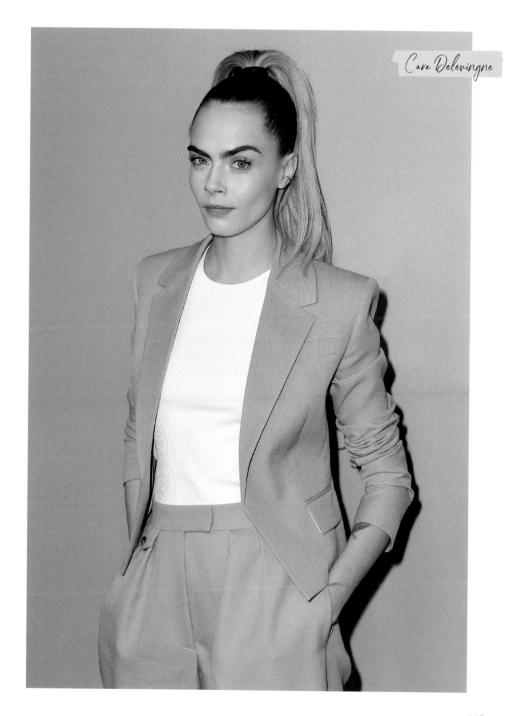

Cara Delevingne

Debby Ryan

DEBBY RYAN: SEXY

People will forget the T was originally made for men if you wear it knotted just below your breasts. High-waisted pants keep this look from being too suggestive.

SVEVA ALVITI: PERFECT WITH PATTERNS

We're down with the white-T-shirt-jeans-jacket combo. With Sveva, this basic piece means you can add patterned shoes. Fabulous!

SUI HE: TWISTED

For a draped effect, you can always knot the T so it doesn't look so basic. Paired with loose-fit, high-waisted jeans, it has real attitude.

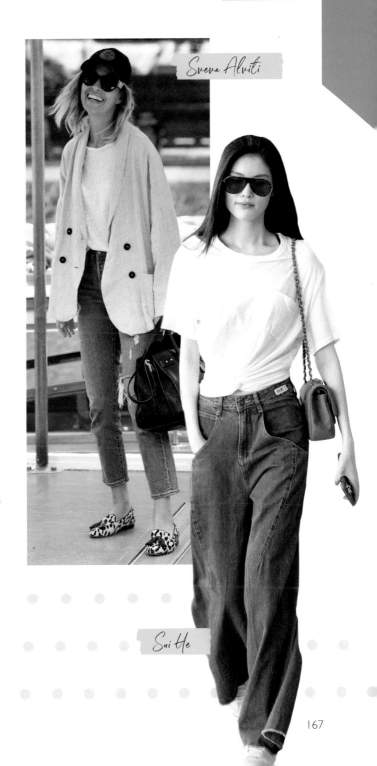

Sveva Alviti

Sui He

167

CATHERINE
DENEUVE

TUXEDO JACKET

If there's one piece you'll never regret having in your wardrobe, it's a black tuxedo jacket. It absolutely never goes out of fashion. The dinner jacket was designed in 1860 in England for Edward VII. In the 1920s and '30s women asserted their independence by donning it. It was Yves Saint Laurent who officially added it to womenswear, calling it *Le Smoking* and making it an alternative to a dress as eveningwear. Here are five ways to wear this essential piece.

THE TUXEDO JACKET LOOKS GREAT WITH EVERYTHING

Pencil skirt, pants, long skirts—even miniskirts and shorts. It also goes well with denim.

WEAR IT WITH A CAMISOLE OR TANK TOP

A white T-shirt works, too, in cooler weather, as does a white button-front shirt, for those who want to stick to the jacket's sophisticated style.

FOR A SENSUAL LOOK GO BARE UNDERNEATH

Seduction guaranteed.

WHEN THE DRESS CODE IS "BLACK TIE"

Better put those high heels to work, as well.

FOR A TOTAL BLACKOUT

Gilded necklaces—like the ones Jennifer Aniston is wearing—provide a bit of sparkle that keeps things from getting too serious.

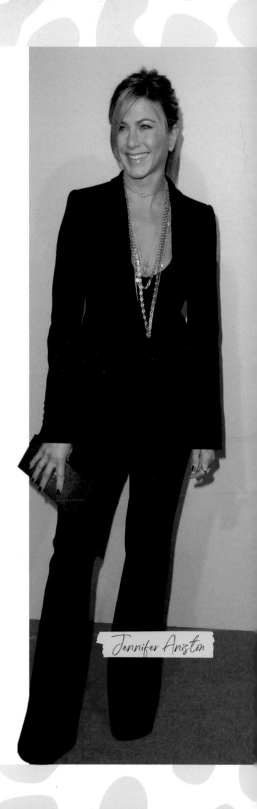

Jennifer Aniston

CYBILL
SHEPHERD

BLAZER

ANOTHER ITEM BORROWED FROM MENSWEAR, THIS NAUTICAL CLUB JACKET HAS LOOSENED UP SINCE ENTERING THE FEMALE WARDROBE. BACK IN THE DAY, WOMEN WORE IT WITH A DEGREE OF SERIOUSNESS; TODAY, THE BLAZER HAS BEEN REINVENTED TO AVOID STUFFY CLASSICISM. NO TIE REQUIRED.

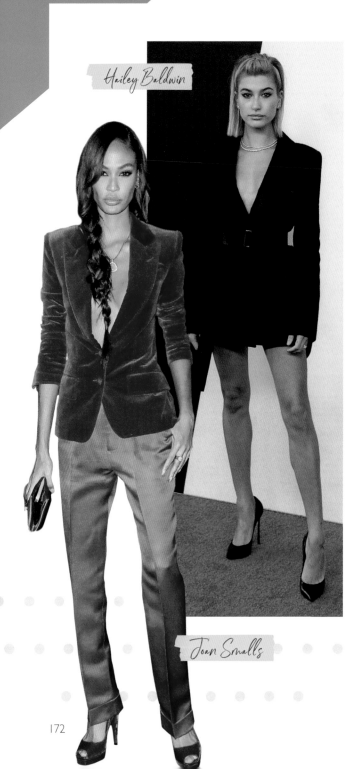

Hailey Baldwin

Joan Smalls

JOAN SMALLS: SULTRY

This red velvet blazer, worn over bare skin with coordinating satin trousers, is highly sensuous.

HAILEY BALDWIN: SUIT DRESS

Worn as a dress, with a belt and towering heels, this "all-in-one" blazer is not for the faint-hearted. Expect to be asked if you forgot something.

KATE MOSS: ALMOST FORMAL

What about wearing shorts with a blazer? Ms. Moss shows us that it's a great look—especially with the help of ballet flats.

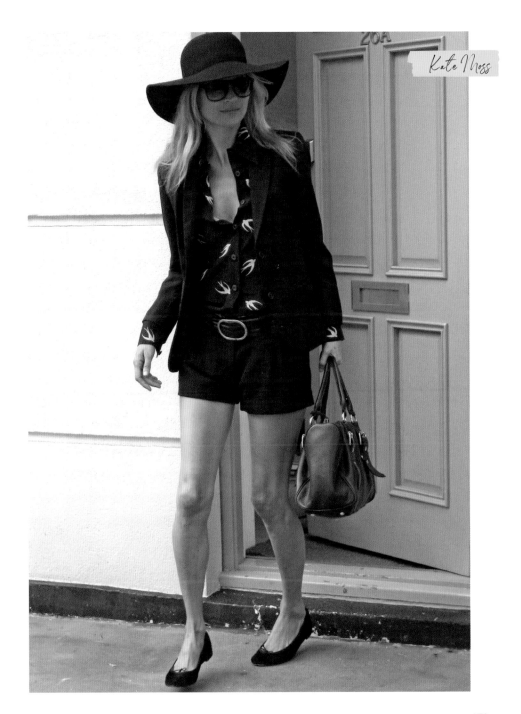

Kate Moss

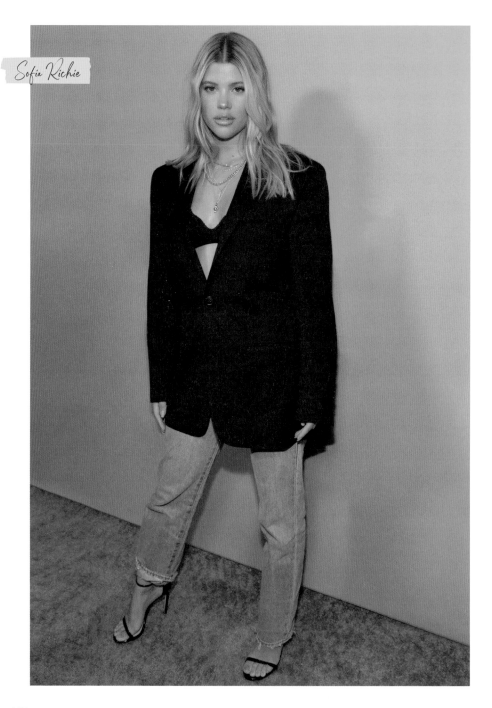

Sofia Richie

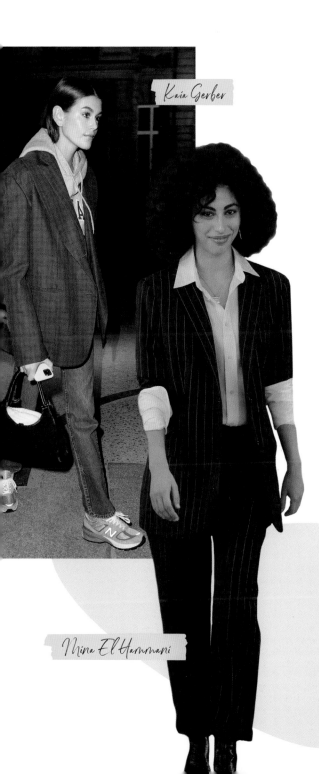

Kaia Gerber

Mina El Hammani

SOFIA RICHIE: UNDERWEAR AS OUTERWEAR

To make an impression without revealing too much, go with a pretty bra—add jeans and heeled sandals. It's simple but memorable: "Do you remember? That was the night Sofia showed up with nothing but a bra under her blazer."

KAIA GERBER: CASUAL

Take note of this new combo: blazer + hoodie + jeans + sneakers.

MINA EL HAMMANI: THE UNIFORM

Paired with matching pants, the blazer becomes a "suit," which is always elegant. Here's an easy idea to steal: fold your cuffs up over the blazer sleeves.

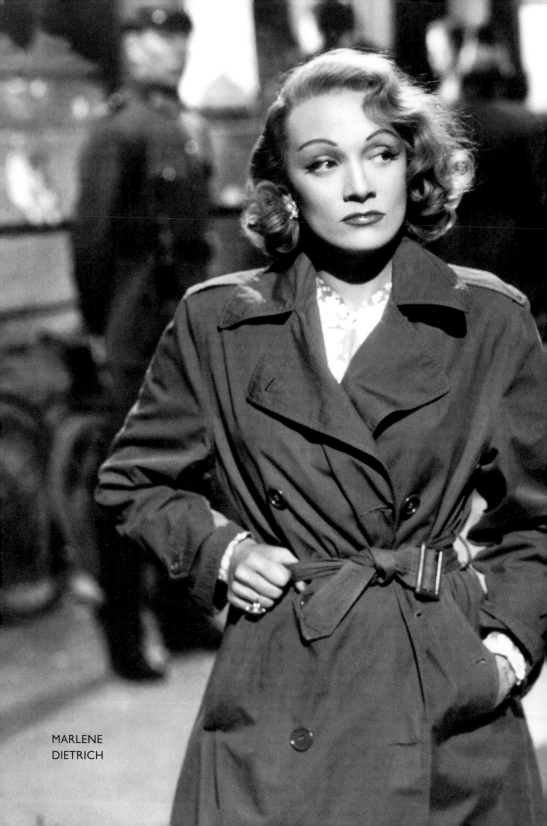

MARLENE
DIETRICH

TRENCH COAT

IT WAS CREATED BY THOMAS BURBERRY IN 1914 TO PROTECT SOLDIERS FROM BAD WEATHER DURING WORLD WAR I. BY THE END OF WORLD WAR II, THE TRENCH HAD MADE ITS WAY INTO CIVILIAN WARDROBES: THE MALE STARS OF FILM NOIR SWORE BY IT. SOON, WOMEN, TOO, ADOPTED THE CLASSIC RAINCOAT. A WATERSHED MOMENT.

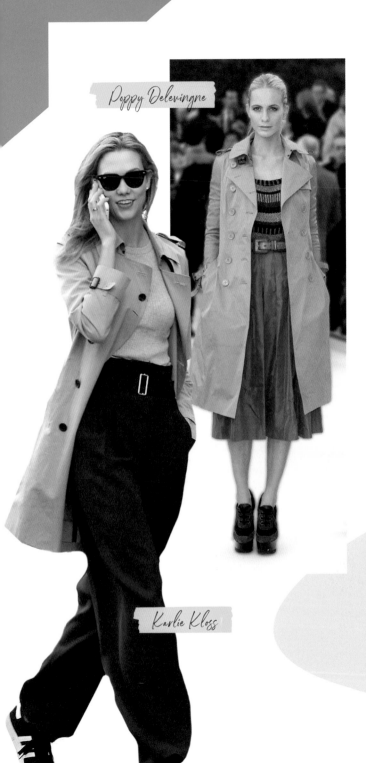

Poppy Delevingne

Karlie Kloss

KARLIE KLOSS: SPORTY-CHIC

With high-waisted pants, T-shirt, and sneakers, the trench fits right in with New York style. Of course, in this scenario it should never be belted.

POPPY DELEVINGNE: SO BRITISH

The Englishwoman knows she's got the home advantage when it comes to the trench coat. Hers is by Burberry; a voluminous skirt and vintage shoes give it extra prestige.

CAMILLE CHARRIÈRE: LUXE

A leather version, worn with patent leather heels and a small handbag, has luxury cred.

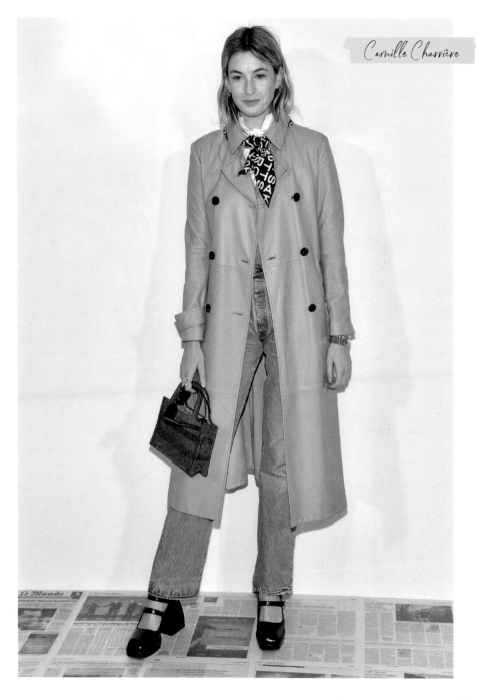

Camille Charrière

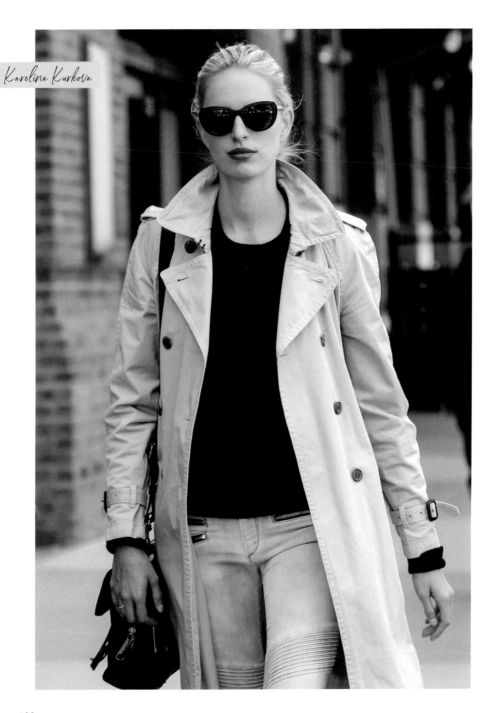

Karolina Kurkova

KAROLINA KURKOVA: DISARMING

Light-wash jeans and a black sweater: there's nothing new there. But with a stroke of scarlet lipstick, Karolina makes it easy to forget that the trench was originally menswear.

MICHELLE WILLIAMS: CLASSIC

The trench goes well with fashion classics like a Louis Vuitton monogram bag, Converse sneakers, jeans, and a bandanna.

DOUTZEN KROES: CHIC

Worn over a sensuous dress, it could almost work on the red carpet.

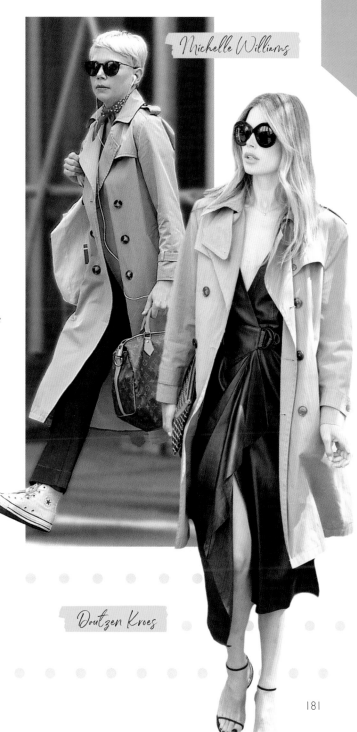

Michelle Williams

Doutzen Kroes

181

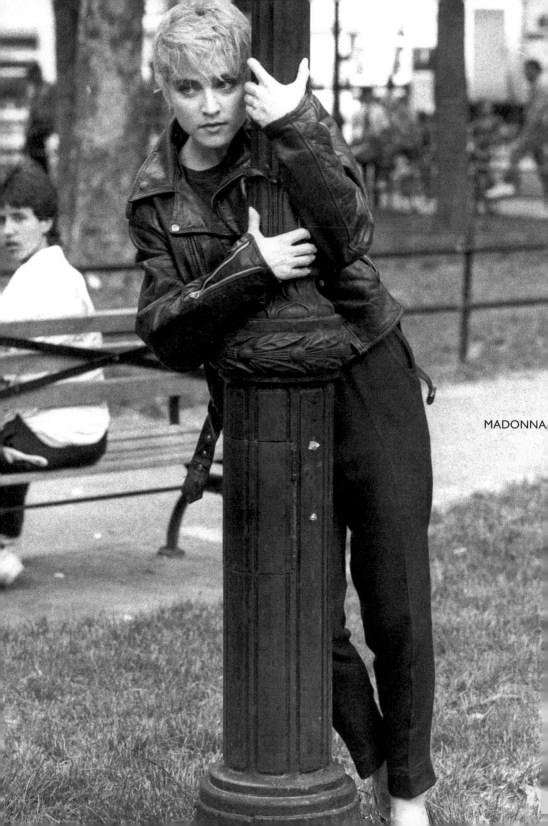

MADONNA

BIKER JACKET

SOME WOMEN SWORE IT WOULD NEVER MAKE IT INTO THEIR CLOSET, BUT THE BIKER JACKET HAS MANAGED TO ENTER MOST STYLISH WARDROBES. THE ORIGINAL, CALLED A PERFECTO, WAS CREATED IN 1928 BY IRVING SCHOTT FOR MOTORCYCLISTS. TODAY, WOMEN LIKE IT FOR ITS ROCK 'N' ROLL APPEAL.

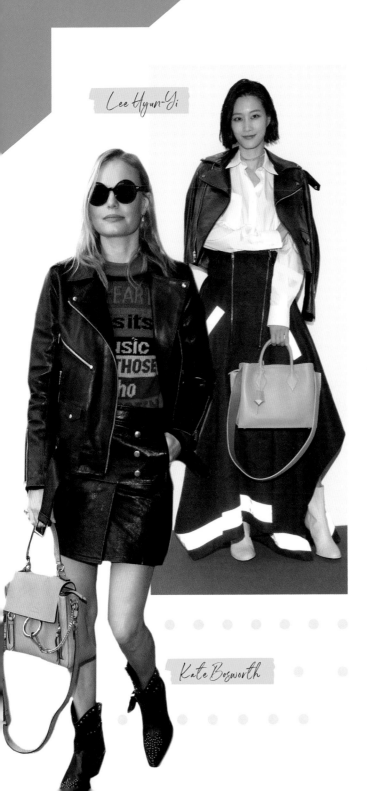

Lee Hyun-Yi

Kate Bosworth

KATE BOSWORTH: COORDINATED

Who would have thought you could wear this jacket with a leather skirt and cowboy boots? Kate tried it and, paired with a colorful sweater, the look works.

LEE HYUN-YI: FASHIONABLE

A white shirt, a skirt in unexpected proportions, and a beige bag: this jacket is resourceful enough to incorporate any style.

JESSICA ALBA: SENSIBLE

She had the bold—but fashionable—idea to wear a striped sweater with a flowery skirt. She wagered—successfully— that a black jacket would tone down the look.

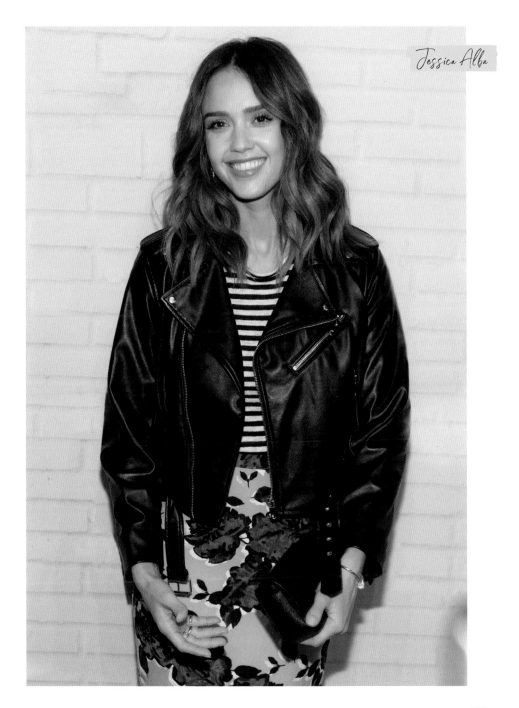

Jessica Alba

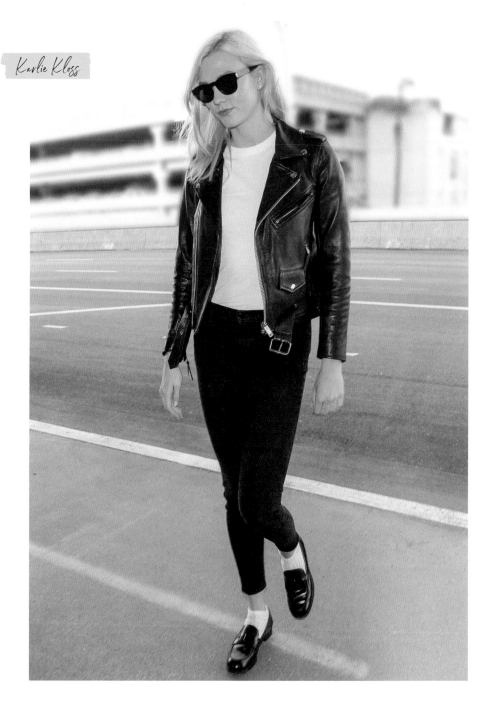

Karlie Kloss

KARLIE KLOSS: ULTRASIMPLE

You can't get any more classic than this, with black jeans and a white T-shirt, white socks, and black loafers. Is she getting ready to moonwalk?

MEGHAN MARKLE: FEMININE

Even a woman of her status can don this black jacket for an evening out. Here, she pairs it with a sexy dress—a great way to avoid looking overdressed.

CINDY CRAWFORD: TIMELESS

Cindy proves age is just a number when it comes to wearing a motorcycle jacket. Striped sweater, slim jeans, and boots are basics that work well with this legendary leather jacket.

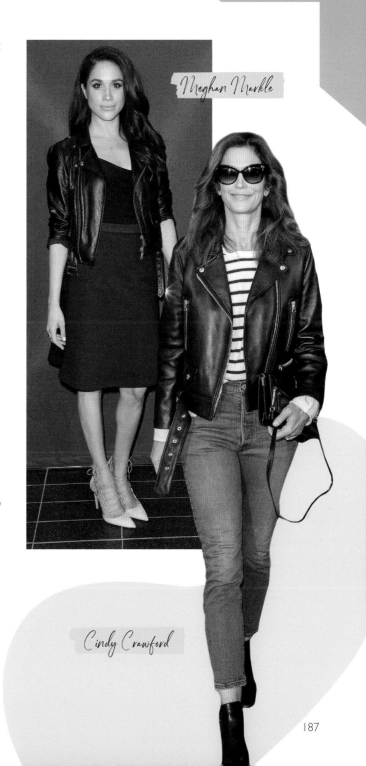

Meghan Markle

Cindy Crawford

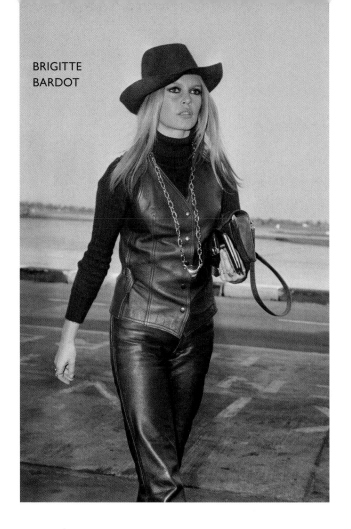

BRIGITTE
BARDOT

LEATHER
PANTS

Not just for rock stars and bikers, today these pants are as classic as jeans. And like jeans, they are multipurpose. They can lend a rock 'n' roll edge just as easily as they can be adapted to a luxury look. And you can wear them at any age— you just have to know how to tame their bad-boy tendencies.

IF YOU WANT
THE ORIGINAL

A black pair will never go out of
fashion, and you can dress it up in so
many ways. But the burgundy version
also has its devotees—as does olive
green (less common, but rather chic).

AVOID FALLING INTO
THE CLICHÉ TRAP

Steer clear of stilettos—ballet flats or
low boots are a much better option.
Spool heels are a good compromise.

IF YOU'RE WEARING
COLORED LEATHER PANTS

Your top can only be black. But with
black pants, anything is possible.

EVEN IF SOME PURISTS
SWEAR BY REAL LEATHER

Animal lovers assure us that imitation
leather leggings do the trick.

FOR AN EVENING LOOK

It couldn't be simpler: they look sharp
with a tuxedo jacket.

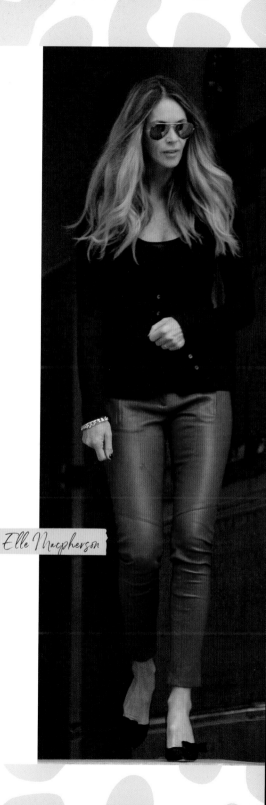

Elle Macpherson

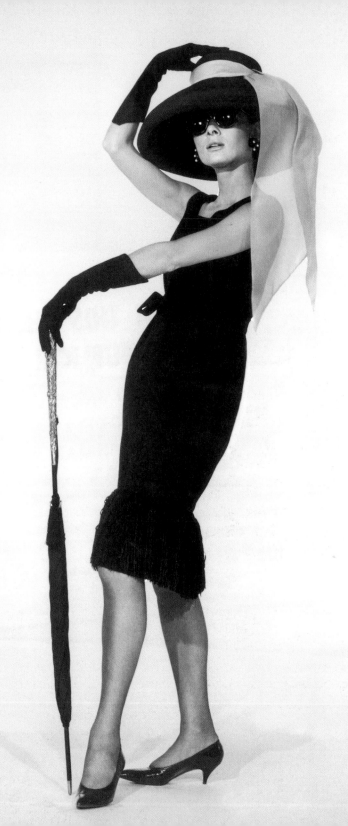

AUDREY
HEPBURN

LITTLE BLACK DRESS

IN 1926, COCO CHANEL ELEVATED THE LITTLE BLACK DRESS TO STAR STATUS. THE SUPER SIMPLE CUT PROVED THAT STYLE DOESN'T HAVE TO BE COMPLICATED. AUDREY HEPBURN, DRESSED BY HUBERT DE GIVENCHY IN *BREAKFAST AT TIFFANY'S*, IMMORTALIZED THE GARMENT. THE SECRET TO MAKING IT SPECIAL? KNOWING HOW TO ACCESSORIZE IT.

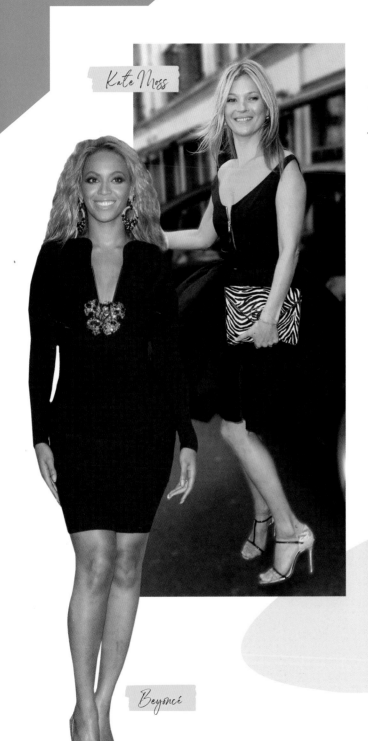

Kate Moss

Beyoncé

BEYONCÉ: BEJEWELED

When a black dress is too austere, you can add jewels to the neckline or waist. Matching hoop earrings aren't necessary—unless you have a show to do.

KATE MOSS: FUN

An expert in the LBD, Kate breaks out eye-catching accessories like a zebra clutch and multicolored sandals. Life is too short to dress dull.

ROSIE HUNTINGTON-WHITELEY: ROCK STAR

With its studded details, this dress is a perfect match for black boots, for those soirées that call for a sophisticated look without going over the top.

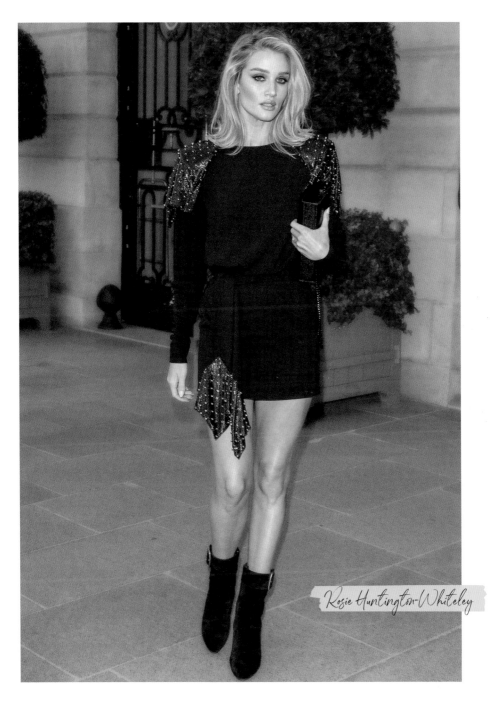

Rosie Huntington-Whiteley

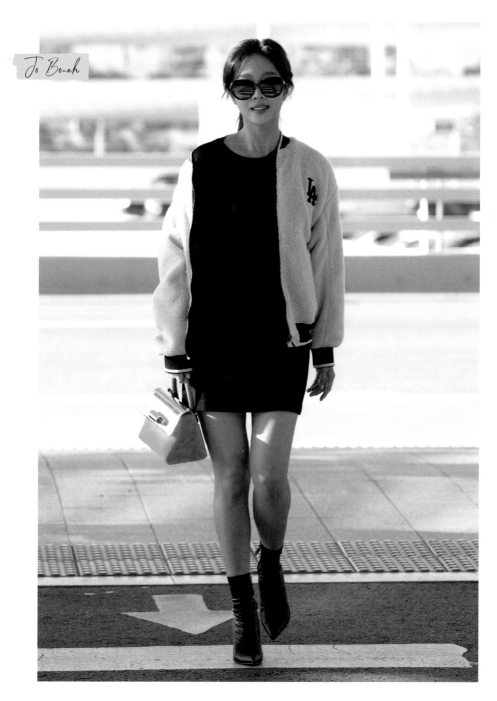

Jo Bo-ah

JO BO-AH: COLLEGE STYLE

Add a pink varsity jacket and a pale pink bag, and the little black dress turns into a teenager's dream.

CARLA BRUNI: LADYLIKE

An iconic Dior bag, movie star shades, pointed heels and *voilà*—we've got a twenty-first-century Audrey Hepburn.

SIENNA MILLER: CLASSIC

This dress by Roland Mouret would be fine without accessories, but to really make an impression, add large sunglasses, earrings, and a cuff bracelet.

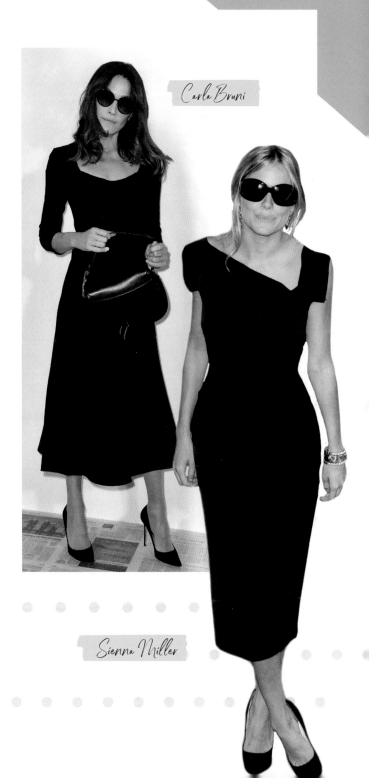

Carla Bruni

Sienna Miller

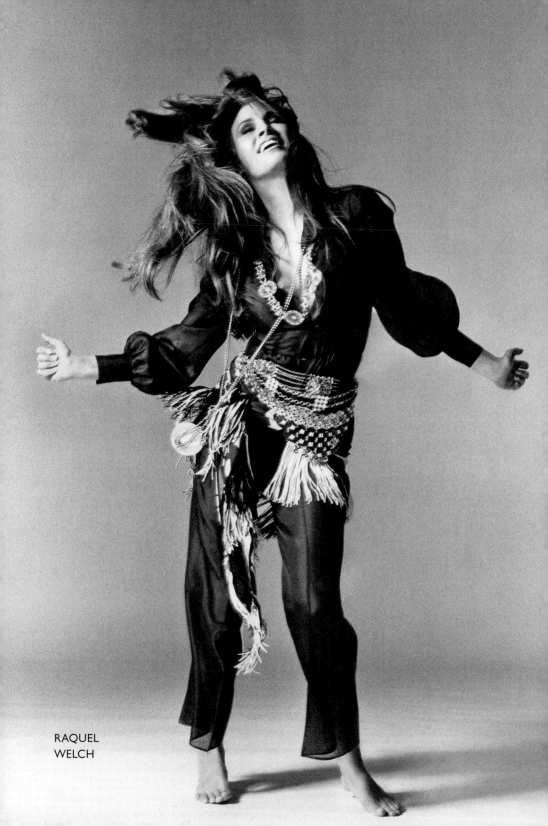

RAQUEL
WELCH

JUMPSUIT

YOU DON'T NEED A PARACHUTE TO WEAR A JUMPSUIT ANYMORE! EVER SINCE WOMEN ADOPTED THE GARMENT DURING WORLD WAR II, AS THEY REPLACED MEN IN THE WORKFORCE, THESE COVERALLS HAVE HELD A PLACE IN THE FASHION HALL OF FAME. DESIGNERS FROM ELSA SCHIAPARELLI TO HALSTON, AND FROM GUY LAROCHE TO COURRÈGES HAVE ALL CONTRIBUTED TO MAKING JUMPSUITS GLAM.

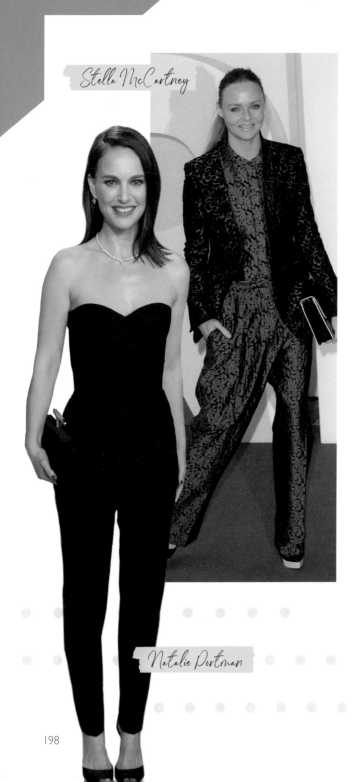

Stella McCartney

Natalie Portman

NATALIE PORTMAN: COUTURE

When an evening dress or a tuxedo jacket just won't do, opt for the bustier. This one-piece, by Christian Dior, proves that it can be seriously sexy.

STELLA MCCARTNEY: COORDINATED

The designer loves jumpsuits, and when she makes one, she adds a matching jacket for special occasions.

CINDY BRUNA: ZIP-FRONT

This zip-up version in unexpected proportions, worn with heeled sandals, makes it easy to forget the jumpsuit was inspired by workwear.

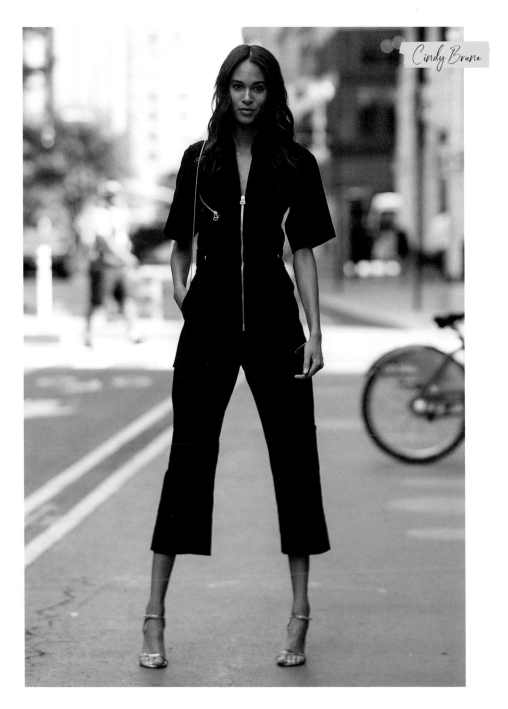

Cindy Bruna

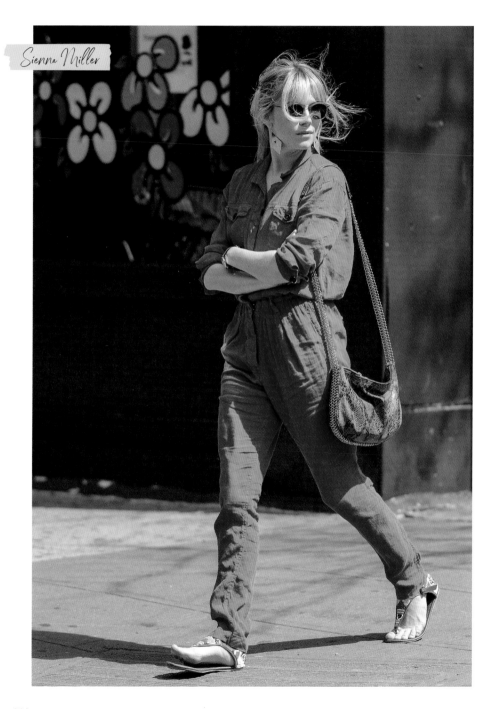

Sienna Miller

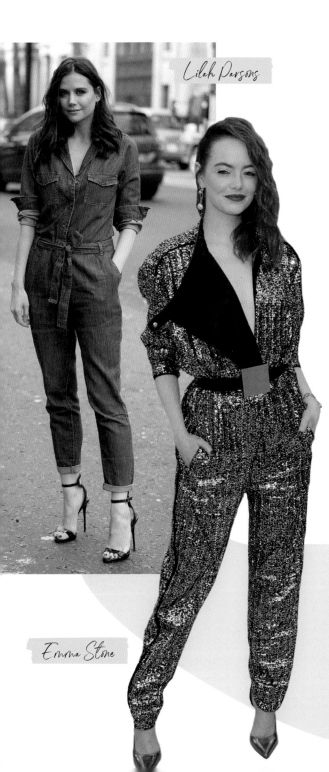

Lilah Parsons

Emma Stone

SIENNA MILLER: BOHO

Worn with thongs and a cross-body bag, this is a roomy, more bohemian version of this style essential, and an unofficial uniform of the urban hippy.

LILAH PARSONS: DENIM

The perfect example of the jumpsuit. Wear it with sneakers as casual daywear, or with heels for a more refined look.

EMMA STONE: DISCO

With a matching gold belt and stilettos, this glittering jumpsuit by Louis Vuitton is guaranteed to create a Saturday night fever.

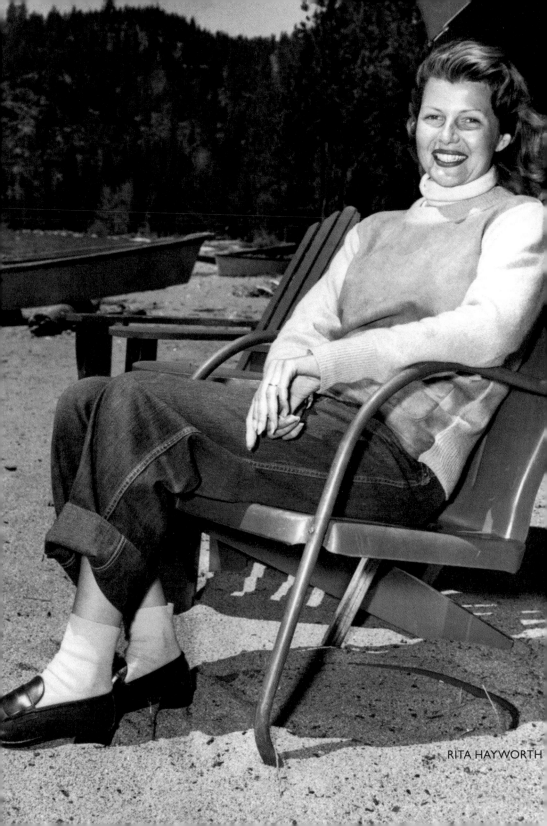

RITA HAYWORTH

DENIM JEANS

DID YOU KNOW THAT THE WORD DENIM IS A CONTRACTION OF "DE NÎMES," FRENCH FOR "FROM NÎMES"? THIS FRENCH FABRIC IS SAID TO HAVE BEEN MADE, ORIGINALLY, FROM A COMBINATION OF WOOL AND SILK. JEANS AS WE KNOW THEM TODAY ARE MADE FROM COTTON AND WERE DEVELOPED IN THE UNITED STATES. ONE THING IS FOR CERTAIN: RARE INDEED IS THE CLOSET WITHOUT A SINGLE PAIR OF JEANS. THIS TIMELESS PIECE WORKS FOR ALL AGES.

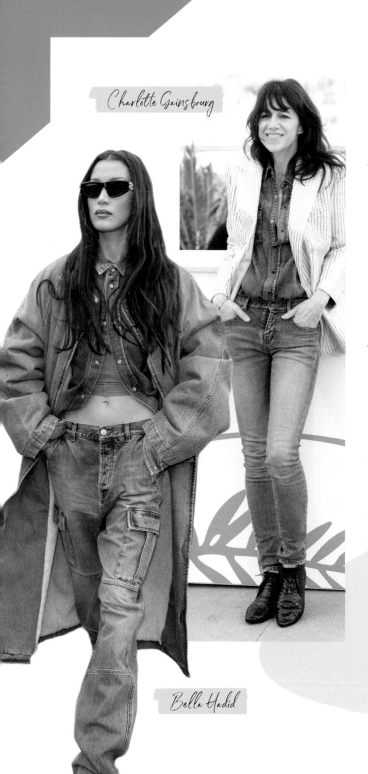

Charlotte Gainsbourg

Bella Hadid

BELLA HADID: CARGO

Jeans don't come only in slim fit: oversize cargo jeans can also have their glory days. Worn with a denim jacket or a simple denim shirt, they add heft to the look.

CHARLOTTE GAINSBOURG: BASIC

Coordinating shirt and jeans, pinstriped blazer, and patent leather oxfords: this outfit works for casual Friday.

ELSA HOSK: HIGH-WAISTED

The great thing about denim is that it really does go with any color—not even neon green can steal its limelight.

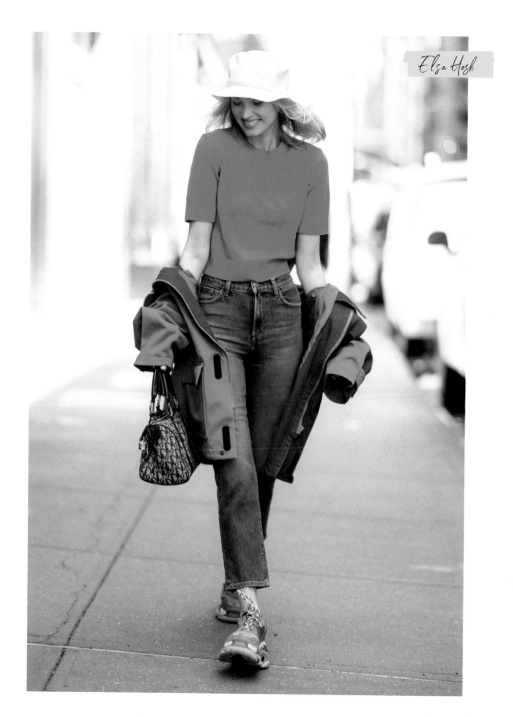

Elsa Hosk

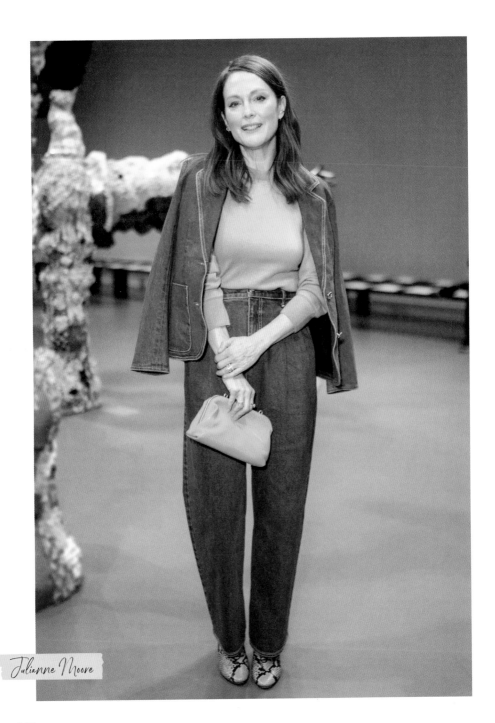

Julianne Moore

206

JULIANNE MOORE: JEAN SUIT

Yes, it's possible to look elegant in denim—Julianne's pantsuit proves it.

ZOË KRAVITZ: ICONIC

Denim devotees know that paired with a sparkly top and heeled sandals, it's perfect for a night out.

STELLA MAXWELL: EASY-GOING

Slightly baggy jeans worn with a crop top, a jacket in the same fabric, and Converse sneakers place this look in the girl-next-door category. Notice the western-style belt.

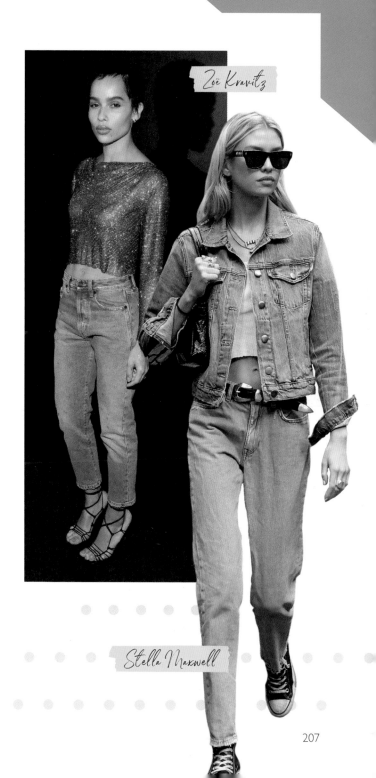

Zoë Kravitz

Stella Maxwell

207

WHITE JEANS

Can they be worn in winter or should they be reserved for summer looks only? Is an all-white look just too washed out? Deciding whether to invest in white jeans raises many questions. If you haven't taken the leap yet, read what you can do with them before making up your mind. If you already have a pair of white jeans, you're in luck: they can be a foundational piece in your wardrobe. Here are five reasons to worship white jeans.

YES, YOU CAN ALSO WEAR THEM IN WINTER

Paired with a colorful turtleneck sweater, for example, they'll brighten up the gray of a gloomy winter.

HEAD-TO-TOE WHITE IS HIGHLY RECOMMENDED

(Yes, even in winter!) It's even more impressive when worn as a suit, for those occasions when you need to look dressed up but want to avoid "predictable" black.

ALWAYS COOL WITH A STRIPED SWEATER

Jenna Lyons, former artistic director at J.Crew and a master at mixing things up, thinks that white jeans go perfectly with a striped sweater, a trench coat 2.0, and white sneakers.

DUSTY ROSE, LIGHT GRAY, NAVY BLUE, OR BLACK

White jeans really go with any hue. And if you want to wear that piece with the crazy print, they'll save you from the "it's laundry day" look.

STAND-OUT ACCESSORIES NEVER FAIL

White shoes are the only matching items permitted.

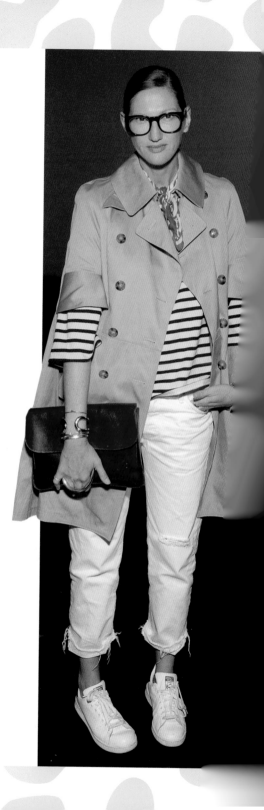

FASHION FAUX PAS... OR FASHION FORWARD?

Everyone interested in sartorial style dreads making a fashion faux pas.
"Is it really that bad to mix patterns?"
"Culottes—in or out?" There are so many fashion "don'ts" that we've always been told to avoid, and yet some women have adopted them as signature pieces, turning heads and standing out from the crowd with their bold sense of style. It's official (so take note!): there is no such thing as a fashion faux pas. The high priestess of fashion Diana Vreeland said, "Too much good taste can be boring. Independent style can be very inspiring." As they say, "Nothing ventured, nothing gained." Here are all the "missteps" we thought were fatal, but which are actually masterful moves.

MIX
PATTERNS

Pairing flowers and plaid is not recommended, unless you're a fashion stylist trying to create an eye-popping photo shoot. According to the rules of fashion, you shouldn't wear more than three colors in the same look and you shouldn't mix patterns. Diane Kruger ignores these diktats and wears a flowered shirt with a plaid suit.

WHY DOES IT WORK?

Because she stays in the same tonal range and is careful to match her belt to the color of her shirt. The same color appears as a line in the plaid—it's subtle, but it makes all the difference. Plus, she opted for a bag and boots in a solid color.

VERDICT: You can mix patterns if you stay in the same tonal palette.

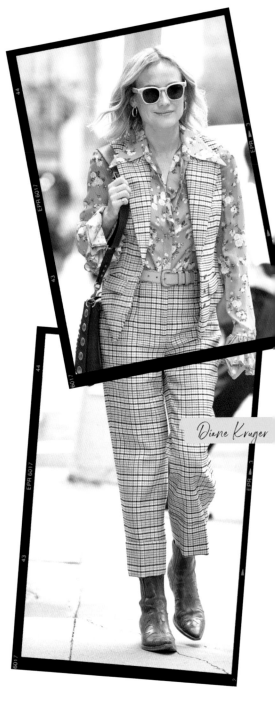

Diane Kruger

GET BRANDED

Women with style—many of them Parisians—say it's tacky to give a company free advertising when you've paid for the garment. Especially if it was expensive. In the last few years, that rule, like all rules, has been flouted: showing off your style by stepping out in branded clothing will earn you points among the fashionistas. Supermodel Elsa Hosk isn't afraid of bad taste—she even leans into it, wearing black thigh-high boots, the tackiest of tacky.

WHY DOES IT WORK?

Because she tempered the look with stonewashed jeans. Those boots are risky—*Pretty Woman*'s Vivian would love them—but they're not paired with a latex skirt, so they get a pass.

VERDICT: To pull it off, tone it down with denim.

Elsa Hosk

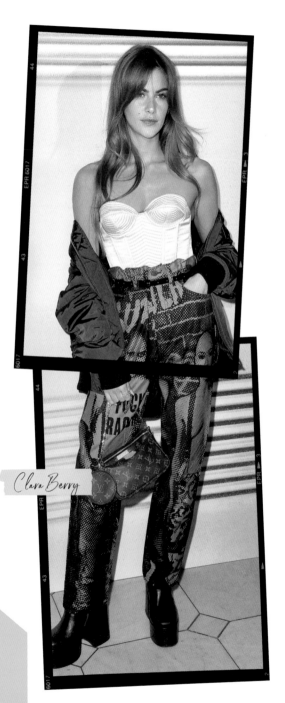

Clara Berry

UNDERWEAR AS OUTERWEAR

A corset as top is a signature of designer Jean Paul Gaultier. Madonna wore one non-stop on her Blond Ambition Tour, but can anyone but the Material Girl carry off a corset in everyday life? French model Clara Berry has found the right way to wear a corset without looking like she forgot to put on a shirt.

WHY DOES IT WORK?

Because Clara "dresses up" her corset: high-waisted printed pants, an oversize satin jacket, and heavy boots. On her, you might almost forget the corset started out as lingerie.

VERDICT: A corset is a great way to add a fresh twist to your style, without baring all. Just don't pair it with a miniskirt.

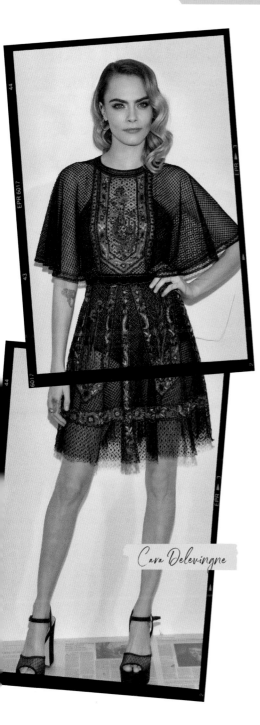

Cara Delevingne

LOSE THE BRA

• • • • • • • • •

Symbol of oppression or female empowerment? Torture device or wonder garment? Certain women are starting to realize that the bra isn't so indispensable after all. However, if you decide to go braless, be sure to focus on your posture—it's essential. Stand tall, like Cara Delevingne who, rather than allowing a bra to detract from her delicate lace dress, simply goes without.

WHY DOES IT WORK?

Because with this dress, the eye focuses not on an exposed chest but on the pattern and embroidery of the garment.

VERDICT: Braless does not mean tasteless. Going bare under a blazer or braless under a translucent top with strategically placed lace is sexy, not trashy.

GO NAUTICAL

Fashion designers love to borrow from military uniforms to create clothes for civilian life. With her striped top and sailor pants, the Duchess of Cambridge, Kate Middleton, follows this to the letter. This look could have been a shipwreck, but she pulls it off royally.

WHY DOES IT WORK?

Because she wears her sailor outfit with heels and a red clutch, which keep her from looking like a member of the Royal Navy.

VERDICT: To avoid looking like you've enlisted, give your uniform a bold twist: a gold belt, studded bag, or sequined sandals—go hook, line, and sinker to counterbalance the nautical look as you navigate toward more glamorous waters.

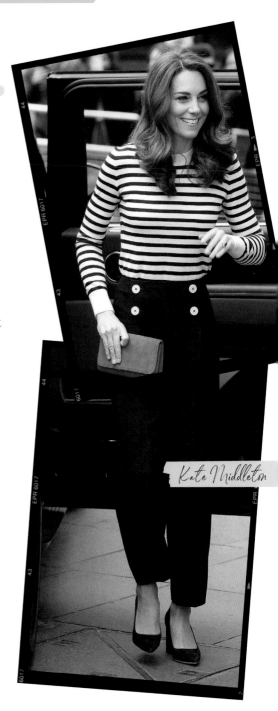

Kate Middleton

SHORT SOCKS WITH A SHORT SKIRT

• • • • • • • •

Trendsetting New Yorkers like Chloë Sevigny always hold space in their closets for the schoolgirl look. The actress often appears in flouncy miniskirts with a romantic blouse, loafers, matching socks, and a beret.

WHY DOES IT WORK?

Let's be honest: this is a hard look to pull off past a certain age, but she carries it off through sheer force of personality. It helps that she stuck to black and white.

VERDICT: This particular outfit is best reserved for middle schoolers, but anklet socks and loafers with a longer skirt could win a spot in the stylish wardrobes of women of all ages. Otherwise, unless you're a critically acclaimed Brooklyn-dwelling indie actress, it's probably best to avoid this look.

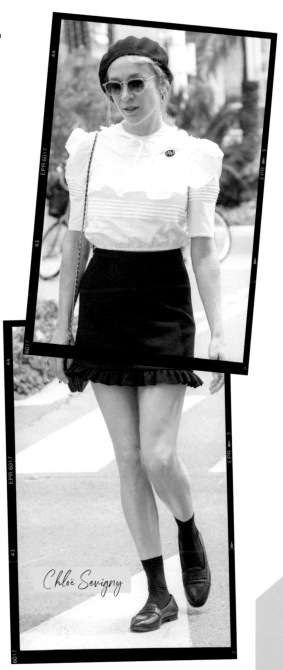

Chloë Sevigny

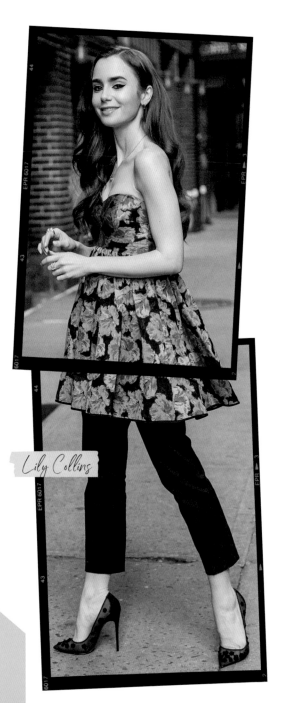

Lily Collins

A DRESS OVER PANTS

● ● ● ● ● ● ●

Typically, it's a dress or pants. But Lily Collins isn't the type to follow rules made up by who-knows-who: she wears a printed bustier minidress over black pants, and the combination makes for a lovely silhouette.

WHY DOES IT WORK?

Because the pants are cut straight and not too wide. And because she vamps it up with heels.

VERDICT: If you're not comfortable with the length of your dress, this is the solution. Obviously it has to have enough volume that it won't stick to your pants. Another combination that works well is a knee-length flowing dress (like a summery print) over a pair of jeans. Belt the dress around the hips to avoid the "oops, I forgot to take off my pants when I put on my dress" look—that's all there is to it!

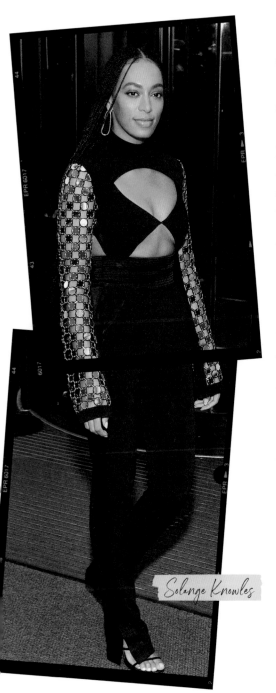

Solange Knowles

DARE
TO BARE

Solange Knowles is an artist who
loves pushing the limits of fashion.
This jumpsuit (by David Koma)
with its daring cutouts is—let's
face it—difficult to pull off.

WHY DOES IT WORK?

Because the jumpsuit is
understated, despite the metallic
details. The same design in a bold
color, like turquoise, say, would be
better kept for the stage. The fact
that it's black makes the look.

VERDICT: Wear this when you
want to make an entrance, for
sure. Still, looks that are "too sexy"
are rarely chic, so whether you
wear this kind of outfit or not
really depends on the style you
want to project. Food for thought:
whoever finds the secret to uniting
sexy and chic in a single look could
rule the world.

MAXIMUM OVERSIZE

• • • • • • • • •

Lady Gaga doesn't do anything
half way—that's just not in her
vocabulary. So when the singer
reaches for oversize, she doesn't go
for something one size up, she goes
for maxi oversize—you could easily
fit two people in this suit.

WHY DOES IT WORK?

Because the suit, in a neutral
color, has structure, despite its
maxi size. And because she's
not wearing anything underneath.
This is a shining example of
the androgynous masculine/
feminine style.

VERDICT: Volume gives a certain
style, and looks less inhibited than
a fitted suit with a cinched waist.
Borrow from an XXL friend, or
look in the men's department for
an XXL worthy of the name!

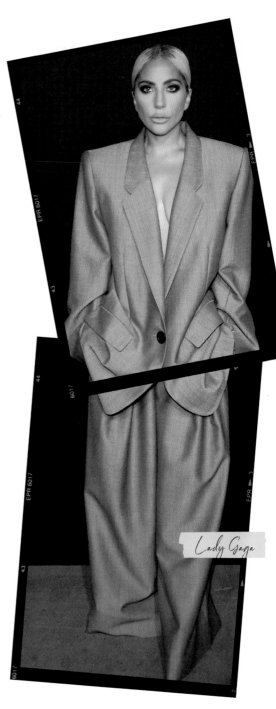

Lady Gaga

HEAD-TO-TOE NUODE

· · · · · · · ·

This is one of the hardest looks to wear, yet it's so easy to put together. The biggest issue with wearing a nude color is that, from afar, it looks like you're naked, so you'd better be prepared to turn heads. That's not a problem for the singer Halsey, who often dyes her hair pink.

WHY DOES IT WORK?

Because she's wearing neon pink heels to draw a little attention away from her plunging, low-cut, high-leg bodysuit.

VERDICT: Maybe not recommended for everyday wear (unless you're a singer who collaborates with K-Pop groups). But when the nude total look consists of a basic shirt and pants, it can actually be pretty elegant. And brightly colored heels are always a good idea.

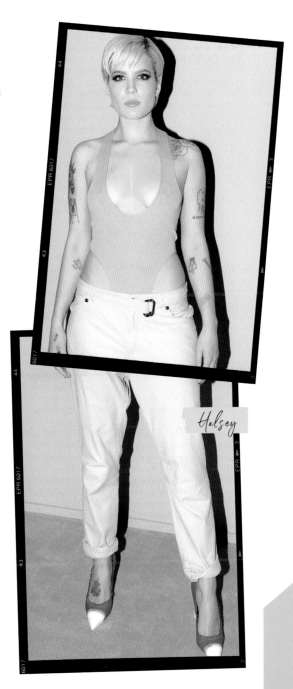

Halsey

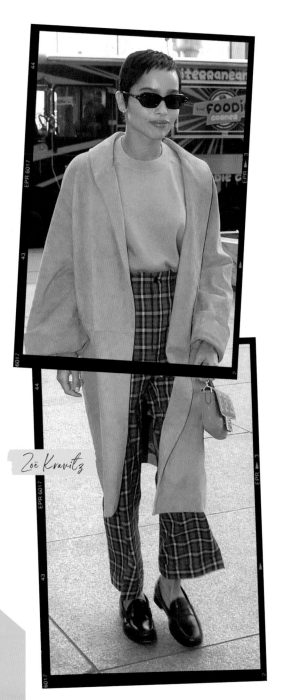

Zoë Kravitz

PLAID PANTS

● ● ● ● ● ● ● ●

"Did you join the circus?" You can expect this kind of question when you dare to wear plaid pants. While a plaid jacket is easy to wear with jeans, tartan trousers can easily verge upon clownish. And yet Zoë Kravitz manages to make this garment cool.

WHY DOES IT WORK?

Because the accompanying pieces are all classic: loafers, a soft jacket, a cashmere sweater, and a small designer bag.

VERDICT: When you wear plaid pants, keep the rest of the look simple—but that doesn't mean bland. Own your look, and you can dress it up with a neon bag and a bright sweater. If you're going to dress like a clown, at least be a fashionable one.

MATCHING TIGHTS AND SHOES

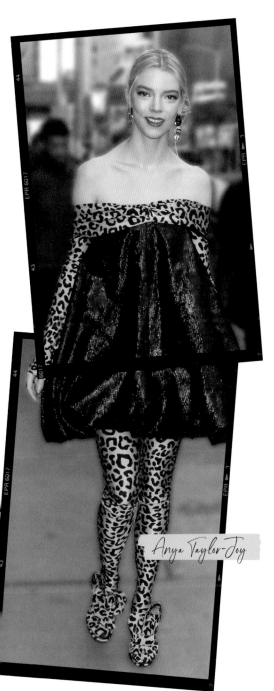

Anya Taylor-Joy

You might think Anya Taylor-Joy is headed to a costume party. But after investigation, it turns out that this outfit is straight from the Halpern collection, proving that matching tights and shoes get the designer stamp of approval.

WHY DOES IT WORK?

Because it's so over the top that it looks sophisticated. And because the black dress tones down the leopard print. Try the same thing with a red dress and you'll be headed for disaster.

VERDICT: It's not always easy to find shoes in the same color or print as your tights, but when you do, don't hesitate to try this out—it'll brighten up a dreary winter day.

UNITE RED AND PINK

• • • • • • • •

These two colors, together, can be an eyesore—but that's also what makes them an interesting combination. Sarah Jessica Parker, known for her daring style, wears pink pants and an orangey-red blouse without batting an eyelid.

WHY DOES IT WORK?

Because for Ms. Parker, alias Carrie Bradshaw in *Sex and the City*, fashion is an eternal celebration. Sequin skirts or clashing colors—the brighter the better. And with white heels, anything goes.

VERDICT: Daring to wear contrasting colors should be part of any fashion exploit. Don't be afraid to try dangerous combinations—that's also part of creating a style. Low-key looks rarely stop traffic.

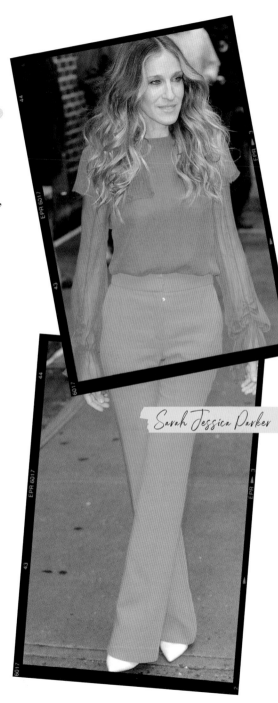

Sarah Jessica Parker

FISHNET TIGHTS

● ● ● ● ● ● ●

Now here's a pair of tights with a bad reputation. They just can't seem to shake their working girl image. But that just needs to be reframed: think Marilyn (Monroe) and Ava (Gardner) in the 1950s, and you'll realize their power of seduction. Now the singer Camila Cabello, in a Valentino total look, proves that fishnets can turn up the heat without looking vulgar.

WHY DOES IT WORK?

Because although her dress is graphic, it's in no way provocative. And because she wears them with boots, not stilettos.

VERDICT: Fishnets have moved on from their sketchy origins. Choose a pair with small, delicate diamonds.

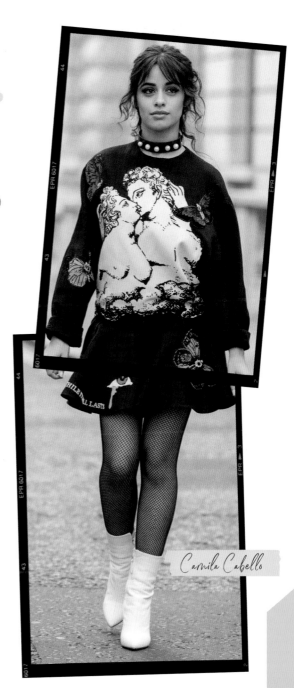

Camila Cabello

Seolhyun

WHITE ANKLE SOCKS WITH HEELED SANDALS

● ● ● ● ● ● ● ●

Here's a combo that took a long time to tiptoe out of the closet. Besides the fact that white ankle socks are a throwback to childhood, it's hard to say that this look (with a minidress) is very harmonious. And yet Seolhyun, a South Korean K-Pop star, is one of the country's most stylish girls.

WHY DOES IT WORK?

Because the sandals are white and green, like the socks. The fashion mix is already quite disconcerting; Seolhyun is right not to overdo it.

VERDICT: On this star, the look is a match point; it works best on the younger crowd.

Dua Lipa

PAIR TWO NEON COLORS

● ● ● ● ● ● ●

We're used to thinking of loud colors as the enemy of elegance— and so wearing them together is a complete no-no, unless you're auditioning for Cirque du Soleil. However, the singer Dua Lipa manages to combine a neon pink top with an equally zingy green jacket—and she does it with panache.

WHY DOES IT WORK?

As with the leopard-print tights and shoes, toning down the outfit—in this case with black pants and matching shoes—saves these bold colors from disaster. Dua Lipa adds a black-and-white checkerboard bag, which may not be for everyone.

VERDICT: Forget your preconceptions that neon colors look cheap and pair them (but no more than two) with something black.

A ROMPER WITH BOOTS

● ● ● ● ● ● ● ● ●

Kate Moss pioneered the shorts-and-boots look. But it was reserved for muddy music festivals where rubber Wellington boots paired perfectly with micro shorts. Outside of that context, boots and shorts were a fashion don't. Supermodel Natalia Vodianova takes the look a bit farther than Kate in artsy, pointy-toed boots and a white short one-piece.

WHY DOES IT WORK?

Because it's a total white look and nothing about the outfit catches the eye. The boots seem a little out of place, but they are the only touch of color, so they balance the look.

VERDICT: Heeled boots with shorts (or a short jumpsuit) work if the ensemble looks unified.

Natalia Vodianova

228

THE PREPPY TIED SWEATER

• • • • • • • •

Rita Ora has never been a stickler for fashion rules. Tying a sweater over the shoulders is normally reserved for prepsters who vacation on the coast and need something for the evening breeze. Rita Ora makes a statement by draping a bright yellow sweater over her jacket-clad shoulders.

WHY DOES IT WORK?

She's already paired a plaid jacket with a polka dot shirt, so adding a bright sweater over her shoulders fits right in with these statement pieces.

VERDICT: When you're known as a rule breaker, slinging a sweater over your shoulders becomes subversive, not conventional. This works for now, but it'll seem far less rebellious when everyone starts doing it.

Rita Ora

Caroline de Maigret

LET IT SHINE

• • • • • • • •

It's always tempting to wear something sparkly. Gold, silver, or sequins: they all have the power to add personality—and playfulness, like this pair of gold jeans on Parisian influencer Caroline de Maigret.

WHY DOES IT WORK?

Because Caroline doesn't overdo the bling—no added sequins or stilettos. She's mastered the look by combining the pants with a white T-shirt and sneakers, which means she can wear them during the day without raising eyebrows.

VERDICT: Whether you're wearing silver or gold jeans, a sequin skirt, or a lamé jacket, it's important to keep the rest of the look completely neutral. Try a denim jacket to keep the brilliance in check. And if you really want to wear heels with gold pants, wait until after dark.

Jessica Hart

RED PANTS

Scarlet pants are not necessarily difficult to wear, but knowing how to dress them up can be a headache. It's easy to cross the line and overdo it. Model Jessica Hart has chosen a pair in a flowing sportswear style that's reminiscent of a tracksuit.

WHY DOES IT WORK?

Because Jessica plays it cool with an edgy crop top and black hoodie—with heeled sandals.

VERDICT: Red pants are actually an easy solution when you want to get noticed. Still, if you don't want to draw attention for the wrong reasons, you're better off pairing them with black, white, fuchsia pink, or even pastel colors.
It would be wise to avoid mustard yellow or pistachio green (but then, who would ever want to wear pistachio green?).

AN OVERSIZE SWEATER WITH A SOPHISTICATED SKIRT

· · · · · · · · ·

A winter sweater with a summer skirt? Why not? It's often said that oversize sweaters can only be worn with pants, but why? Can't we combine clothes from different seasons? Supermodel Jourdan Dunn's light skirt cozies up with a wool sweater (by Michael Kors).

WHY DOES IT WORK?

First of all, because it's pretty, but also because the two pieces are in the same pastel tone.

VERDICT: This combination lets you wear summer skirts and dresses in cooler seasons. It also works well if the sweater and the skirt are in different colors. And heels are not mandatory; sneakers make for a more unique—and therefore recommended—outfit.

Jourdan Dunn

LAYER LONG NECKLACES

● ● ● ● ● ● ●

Past a certain age, heavy jewelry is frowned upon (go figure). Young fashionistas who spend their lives on Instagram pile on necklace after necklace, so everybody should ignore this rule. Iris Apfel—a true fashion icon, soon-to-be centenarian, and former White House interior decorator for nine presidents—certainly does. She never leaves home without her armada of necklaces. It gives her a signature look that defines her style.

WHY DOES IT WORK?

Because they're coordinated with her outfit, and they're all more or less the same color.

VERDICT: If you can find necklaces that are the same color as your outfit, you're good to go. Layering also works with bracelets and even rings. Take note: successful layering will earn you a reputation as a pro.

Iris Apfel

CULOTTES

● ● ● ● ● ● ● ● ● ●

This is *the* piece to avoid if you're hoping to flirt—literally no one (in their right mind) finds culottes sexy. They don't flatter anyone, of any shape or age. Honestly, if you never have a pair of culottes in your wardrobe, it's perfectly ok. But Elle Fanning has managed to rehabilitate this much maligned garment.

WHY DOES IT WORK?

Because this suit version doesn't make it immediately clear that she's wearing culottes. And because she strikes an entirely different note by pairing them with a well-structured jacket, a shirt, and a tie.

VERDICT: To carry off culottes, pair them with something in the same color. They'll stay under the radar.

Elle Fanning

CHECK MATES

● ● ● ● ● ● ● ●

Giovanna Battaglia

Just as with contrasting prints, checks of different colors should never meet. And yet Giovanna Battaglia pairs a pink plaid jacket with a yellow plaid skirt. And she does so with aplomb. She knows that these color combinations break all the rules, and yet she owns this look.

WHY DOES IT WORK?

We know that when colors clash, there's nothing better than black to tone everything down. The one detail that everyone can agree on is the gold and pink shoes. They're what make Giovanna a skilled stylista who isn't afraid of explosive mixes.

VERDICT: Different plaids combined with a black sweater and shiny shoes make for a stylish look.

INES DE LA
FRESSANGE

"In order to be irreplaceable, one must always be different."

Coco Chanel

PHOTOGRAPHIC CREDITS

Thanks to:

Julie Rouart, Kate Mascaro, Gaëlle Lassée, and **Helen Adedotun,** who understand that style is about more than a pair of heels, and that kindness is also key to looking good.

Tiphaine Bréguë, one of the best artistic directors in the world and the only one who lives in two time zones.

Orange, Free, SFR, Sosh, and Bouygues, without whom this book would not have been possible.

Brune de Margerie, who proves you can wear black and still shine brightly.

Florence Besson, who always knew that I held the secret to wearing white jeans.

Pascal C., who takes nothing seriously, and who wears a tuxedo jacket with brio.

Nora Bordjah. She knows why.

Patricia Jugnot, who has a certain je ne sais quoi and is going to illustrate my next best seller ;-).

Peggy Frey, who makes fashion fun, even while stuck in coronavirus lockdown.

My colleagues from my days at *ELLE,* with whom I shared more than twenty years of adventures in style.

Véronique Philipponnat, who taught me that our style might be dependent on our G7 taxi account.

Anne-Marie Périer, who embodies the essence of style.

Ines de la Fressange, because, like Paris, "Ines will always be Ines."

Philou and **Mike,** my wonderful neighbors: without the pangolin workshops, I would never have finished this book on time.

Virginie Mouzat, my life coach, who has as much style in matters of fashion as she does in interior design and psychology.

My mother, who is responsible for my love of fashion.

Stan, my "baby," *mon Amour,* who made sure our children were fed while this book was being written.

Aramis, Sienna, and **Vadim,** who are "supermodel" kids and always so patient (thank you YouTube and TikTok).